THEN *&* NOW

SOUTH BOSTON

Opposite: The waterfront in South Boston has long been a bustling area with the docking of passenger and cargo ships, railroad service for freight cars, and the many delivery trucks that delivered and picked up for a multitude of small-business concerns. Seen here in the mid-1950s, the area has a train of the New York, New Haven and Hartford Railroad stopped on the right with delivery trucks in the foreground. This was the bustling area of South Boston's commercial waterfront until just a few decades ago. (Author's collection.)

SOUTH BOSTON

Anthony Mitchell Sammarco
Contemporary Photographs by
Charlie Rosenberg

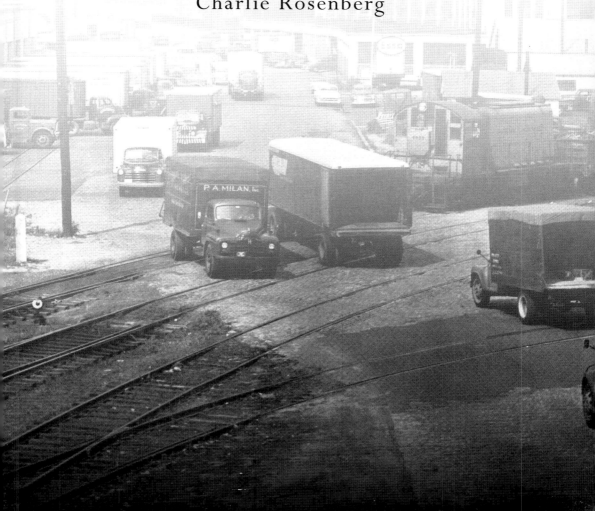

Library of Congress control number: 2005934213

Published by Arcadia Publishing
Charleston SC, Chicago IL, Portsmouth NH, San Francisco CA

Printed in the United States of America

For all general information contact Arcadia Publishing at:
Telephone 843-853-2070
Fax 843-853-0044
E-mail sales@arcadiapublishing.com
For customer service and orders:
Toll-Free 1-888-313-2665

Visit us on the Internet at www.arcadiapublishing.com

In memory of Veronica M. Lehane,
children's storyteller par excellence.

On the front cover: Please see page 24. (Above, courtesy Charlie Rosenberg; below, courtesy Frank Cheney.)

On the back cover: Please see page 47. (Courtesy Frank Cheney.)

CONTENTS

ACKNOWLEDGMENTS

I would like to thank Charlie Rosenberg for his insightful "Now" photographs.

I would also like to thank the following for their assistance in the researching and writing of this book: Robert Allison; Harold Amato, Southie's best barber; Boston Public Library, Print Room, Aaron Schmidt; Frank Cheney; Paul Christian, retired chief, Boston Fire Department; Colortek; Elaine Connolly, president, South Boston Historical Society; Evelyn Connolly; Elizabeth Curtiss; the late Dexter; Cynthia Dromgoole; Margaret Dwinell; eBay; Paula Fleming; Francie Francis; William Gallagher; Daniel Haacker, Milton Public Library; Helen Hannon; Stephen Kharfen; James Z. Kyprianos; Eileen LaRosee; Paul Leo; Gerard Logan; Theresa Lydon; Laurel Moreau; Frank Norton; Ellen Ochs; P. Virginia O'Shea; Michael M. Parise; Fran Perkins; Patricia Reid; Dr. William Reid, president emeritus, South Boston Historical Society; Sue Russell; Anthony and Mary Mitchell Sammarco; Robert Bayard Severy; Alan Siders; the South Boston Branch, Boston Public Library; the South Boston Historical Society; Erin Stone, my editor; George and Anne Flanagan Thompson; the Urban College of Boston; the Victorian Society, New England Chapter; and James Preston Wysong.

INTRODUCTION

As the popular vaudeville song by local composer Benjamin V. (Benny) Drohan goes, "Southie Is My Home Town," and remarkably in the last decade, South Boston has evolved from a primarily tight-knit Irish American neighborhood to a far more diverse neighborhood of the city of Boston; people of all walks of life are moving to this neighborhood due to the convenience to downtown Boston, the wide spectrum of housing available, and the rapid conversion of multiple-family dwellings to condominiums and the infilling of vacant lots with new condominium construction.

Once a 579-acre area known successively as Mattapannock, Great Neck, and Dorchester Neck, South Boston was once a large, remote peninsula that projected into Boston Harbor with close proximity to the harbor islands, among them Castle Island, which since 1892 has been connected to the mainland by a bridge. Throughout the 17th and 18th centuries, South Boston was used primarily for the grazing and pasturing of cattle, with a gate at the area of what became known as Washington Village, now known as Andrew Square. There were only a few families that lived here before the American Revolution, among them the Bird, Blake, Farrington, Foster, Harrington, Hawes, and Wiswell families, and they were associated with Dorchester and belonged to the meetinghouse located there. During the Revolution, the fortification of Dorchester Heights (now marked by a striking and prominent white marble monument) by patriots and headed by Gen. George Washington, forced the evacuation of Boston by the British, and the Loyalists, on March 17, 1776, which became known as Evacuation Day and is a holiday still celebrated throughout the city, and with great éclat a parade in South Boston. However, by the early 19th century, the proximity and convenience of the peninsula to the rapidly expanding town of Boston attracted developers and speculators who saw great advantages to seeing it annexed to Boston. After months of bitter litigation, the town of Dorchester lost its "neck" in 1804, and henceforth it was to be known as South Boston.

Envisioned as the new fashionable residential district, streets were laid out in a grid pattern of numbered and lettered streets with the two major streets being Broadway and Dorchester Street, which intersected Broadway at the center (now Perkins Square). In 1805, the Federal Street (now Broadway) Bridge connected the peninsula to Boston, which began a steady flow of traffic. The building of the Mount Washington Hotel gave rise to the credence that the area would attract new development, especially as it was served by an hourly horse-drawn omnibus from downtown. With the opening of the Hawes School on West Broadway and the fashionable Mount Washington Female Institute on East Broadway, the population quickly multiplied, and with the proximity to the ocean, panoramic views of the harbor islands, and other amenities, the population of South Boston became a substantial and diverse group of residents. The development

literally boomed following the Civil War, with the neighborhood having large tracts of land developed for fashionable housing, among them Thomas Park, which circled around the former reservoir that was eventually to be developed as a park with an elegant white marble monument to the Battle of Dorchester Heights. So much new residential building took place that the population swelled from 23,000 at the time of the Civil War to 67,000 at the beginning of the 20th century, and the infilling of land brought it to 1,333 acres. Like other parts of the city, South Boston attracted a diverse grouping of new residents, many of them new immigrants to the United States.

Thousands of these new residents, like the city of Boston as a whole, came from Ireland, but there were also a large number of immigrants from Lithuania as well as Poland and Italy. Each of these new immigrant groups brought a new vitality to South Boston that added a new spectrum to its development with these residents adding to the distinctive quality of the neighborhood, which rapidly expanded with row houses and three deckers, as well as single-family houses. With new places of worship and new schools, as well as social clubs, South Boston had attained a vibrancy that has been sustained unabated for a century.

In the last decade, South Boston's tight-knit and densely settled neighborhood has attracted many new residents that have also come to call "Southie" their hometown. With increased property values, proximity to beaches and waterfront parks, and continued ease of transportation to the city proper, South Boston has attracted many young professionals who have quickly found the newly created condominium craze a feasible alternative to the high rents of downtown. As the old, familiar streetscapes have been remade with new businesses and storefronts, it has created a thriving nexus of new and diverse people who have chosen to live here, and the current population census averages 30,000. Annually, the St. Patrick's Day parade is held in South Boston with thousands of participants, and spectators, marching along Broadway—from the mayor of the city and the members of the city council to the marching bands of local parochial schools. Although everyone is Irish on this day of celebration, it is actually Evacuation Day that the city is celebrating, the day on March 17, 1776, the British left Boston and the siege was over. However, Southie includes everyone and is truly Boston's hometown.

I had an argument the other day with a guy from Oskaloo
He was braggin' 'bout his old home town;
Says I to him, "What to do," I got hot right under the collar
To that scholar I did holler
I was born down on "A" Street, raised up on "B" Street
Southie is my home town.
There's something about it, permit me to shout it
They're the tops for miles around.
We have doctors and scrappers, preachers and flappers,
Men from old County Down. Say, they'll take you and break you,
But they'll never forsake you in Southie my home town.

CHAPTER 1

ALONG BROADWAY

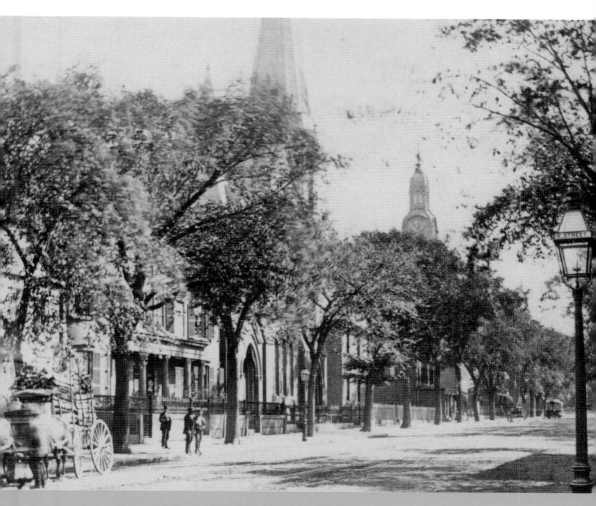

West Broadway, looking from F Street toward Dorchester Street, in the 1870s was a bucolic streetscape of residences, the Hawes School, and the spires of St. John's Methodist Episcopal Church and the Phillips Congregational Church, demolished in 1948. By the late 19th century, this area of West Broadway became the major shopping district in South Boston with the Mount Washington Savings Bank and the Bank of America replacing the churches. (Author's collection.)

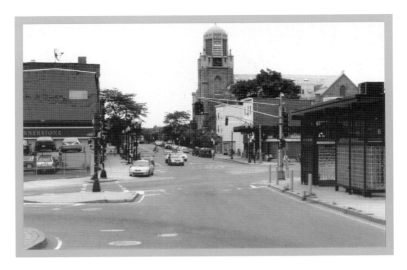

Looking east on West Broadway from Dorchester Avenue in the mid-1930s, SS. Peter and Paul Roman Catholic church can be seen on the right, and the streetscape between the avenue and A Street, on the left, is a composite of stores, taverns, and cafés on the first floor, with apartments above. SS. Peter and Paul Church, designed by Gridley J. F. Bryant, was established in 1845 and was the first Roman Catholic parish in South Boston; the church was closed by the archdiocese in 1995 and has been converted to condominiums. Broadway had been laid out in the early 19th century as the major east–west thoroughfare, divided by Dorchester Street as West Broadway and East Broadway. On the right is the Macallen Building, a former factory, now contemporary condominiums. (Courtesy Frank Cheney.)

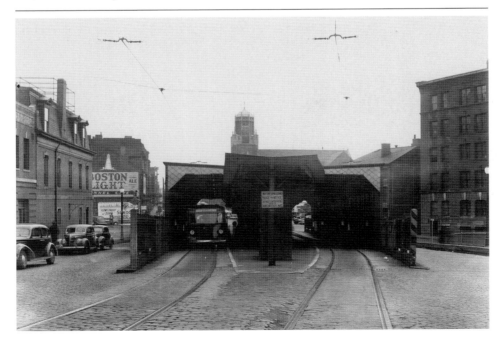

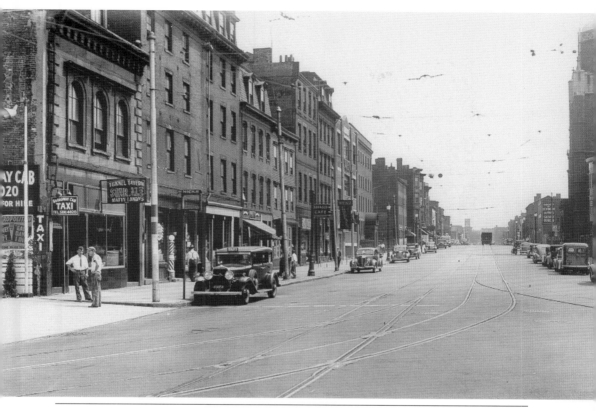

Looking up West Broadway from Broadway Station in 1934, SS. Peter and Paul Church can be seen on the right, as well as a wide array of 19th-century architecture along the left streetscape, including, halfway down, SS. Peter and Paul Catholic School, later Cardinal Cushing High School, and presently the Notre Dame Educational Center. (Courtesy Paul Christian.)

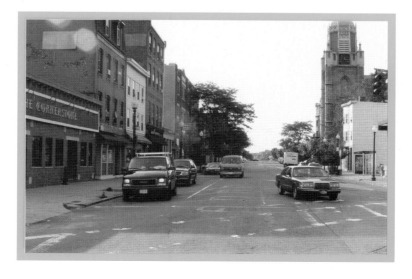

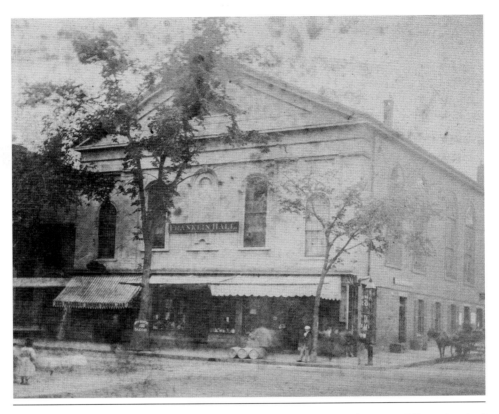

Franklin Hall was a the former South Baptist Church at the corner of West Broadway and C Street. Named for Benjamin Franklin (1705–1790), a Bostonian by birth and later printer, statesman, and inventor of electricity, Franklin Hall was a large meeting space on the second floor that had shops on the first floor, among them a dry goods bazaar and a dining room. Today the area is the former D Street Housing Development, now the St. Casimir Housing Development. (Author's collection.)

ALONG BROADWAY

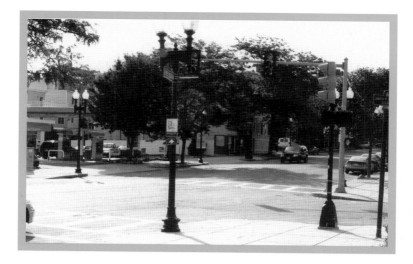

Blinstrub's Village was the famous nightclub of Stanley Blinstrub at the corner of West Broadway and D Street, located in 19th-century buildings that had been remodeled to include crenellated towers and a stone veneer facade. It had fine dining, top-notch entertainment, and dancing, and among the entertainers were Wayne Newton, Nat King Cole, the McGuire Sisters, and Jimmy Durante. Unfortunately, Blinstrub's had a disastrous fire in 1968 that destroyed the extensive and popular nightclub, and it was subsequently demolished. Today Broadway Shell is located at the corner. (Courtesy South Boston Historical Society.)

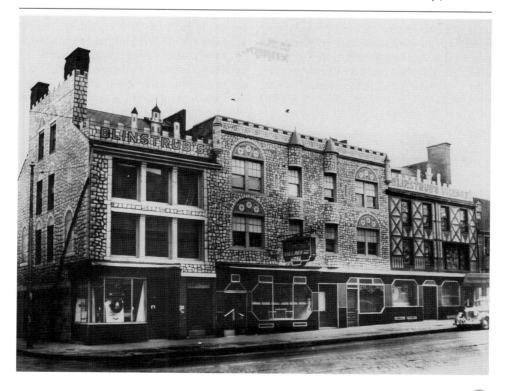

West Broadway at F Street, seen in 1950, has streetcar 3204 bound for City Point, passing the numerous stores and apartments that lined the street. The Nickerson Block, seen on the left, was built in 1899 at 397–401 West Broadway as a Classical Revival apartment house with pressed metal window bays. (Courtesy Frank Cheney.)

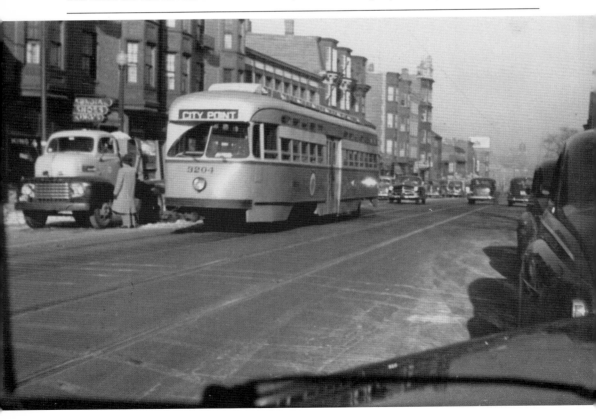

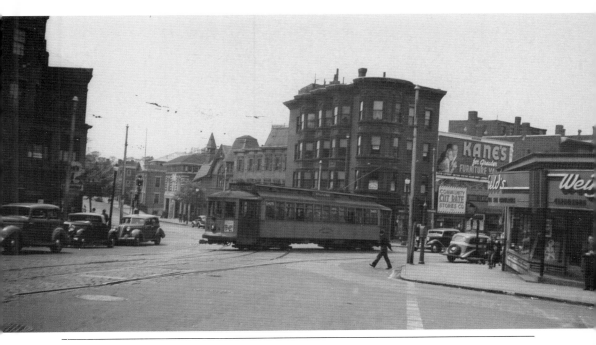

The corner of Dorchester Street and Broadway, seen in 1938, was a bustling shopping area with automobiles and a City Point–bound streetcar at the intersection. The building in the center is the Bowen Block, a distinguished commercial block built by Henry J. Bowen, with apartments above, and just beyond is the Fourth Presbyterian Church. Today Mr. McGoo's is at the corner. (Courtesy Frank Cheney.)

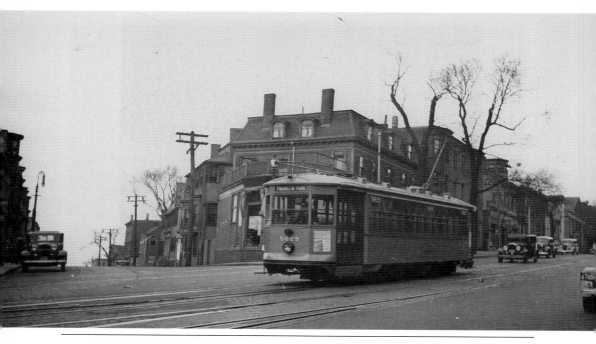

Streetcar 5829 approaches Perkins Square, named for Michael J. Perkins, who was a World War I Medal of Honor recipient, at the junction of Dorchester Street and West and East Broadway. The large houses along "Pill Hill" in the distance were among the most fashionable in the mid–19th century, and the cornerstore (obscured by the streetcar) was the Suter Block, built by John W. Suter. (Courtesy Frank Cheney.)

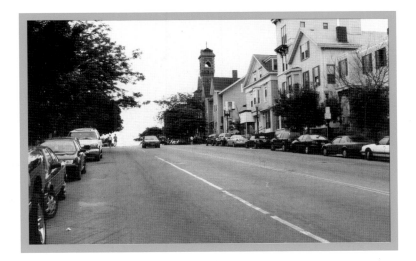

Looking up East Broadway in 1948 from Dorchester Street, Pill Hill, the section of East Broadway between Dorchester Street and H Street and known as such for the many physicians who resided or had their offices located here, creates an interesting streetscape. The lofty spire of the Hawes Unitarian Church (now St. George Albanian Orthodox Cathedral), designed by Samuel J. F. Thayer, can be seen at the crest of the hill with the impressive 19th-century Italianate and Queen Anne mansions, some with shops on the first floor. Mansions, apartments, and shops were all part of the streetscape. (Courtesy Frank Cheney.)

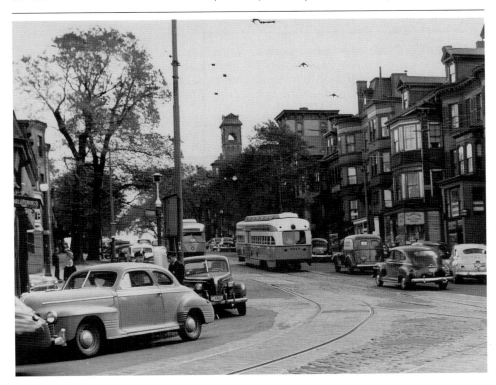

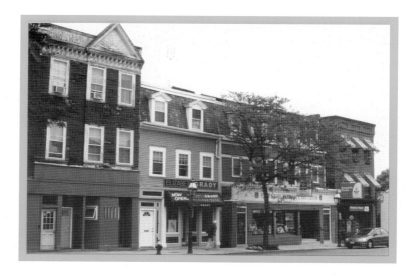

Flood Square was on East Broadway, near the corner of I Street, and was Saphir's, the Flood Square Barber Shop, and the Flood Square Hardware Company. These buildings—614, 616, 618, 620, 626, and 630 East Broadway—had shops on the first floor and apartments above. (Courtesy South Boston Branch Library.)

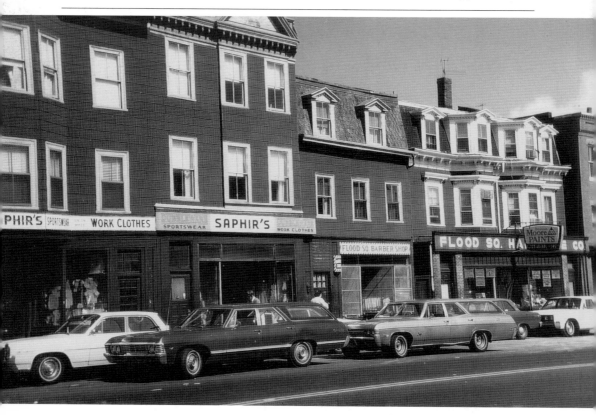

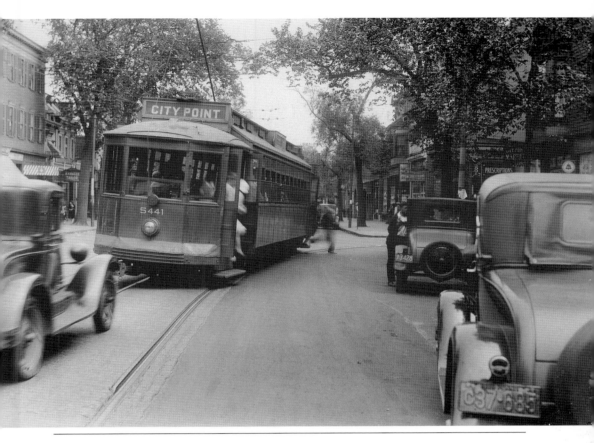

Streetcar 5441 emerges in 1929 from K Street onto East Broadway as it proceeds to City Point. These streetcars were the major reason the neighborhoods of the city were so accessible and convenient. On the left is the Jones Department Store. (Courtesy Frank Cheney.)

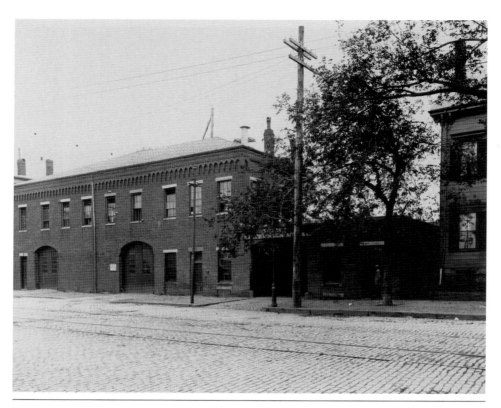

The K Street car house was built in 1865 by the Broadway (later the South Boston) Street Railroad Company on East Broadway between K and L Streets. This brick hipped roof building had stalls for the horses that pulled the streetcars, offices, and a waiting room on the far right. Later owned by the Boston Elevated Railway Company, it had hack, boarding, and livery stables in the rear. Today this is the site of Stop and Shop Supermarket, formerly Flanagan's Supermarket. (Courtesy Frank Cheney.)

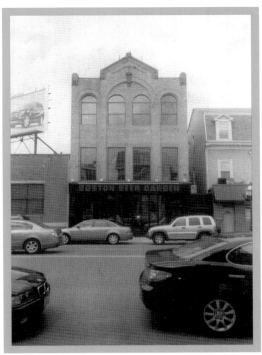

The Pilgrim Hall School was designed by James H. Besarik and built as a yellow brick Queen Anne–Romanesque Revival building in 1890 at 732 East Broadway and was an elementary school for many years. In the early 20th century, it also served as a meeting place for numerous social service groups in South Boston. By the 1960s, the once impressive brick facade housed Cassidy's Café. Today the former school cum café has been converted to the popular Boston Beer Garden. (Courtesy South Boston Branch Library.)

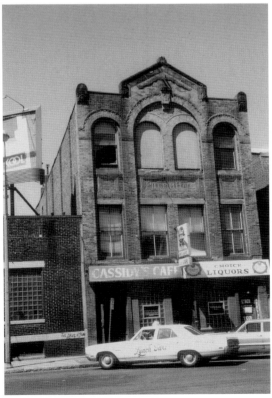

Looking west from L Street in 1937, East Broadway has changed relatively little. The houses on the left and right in the foreground all have shops on the first floor now, and Pilgrim Hall can be seen opposite the streetcar. In the distance is the belfry of the Lincoln Elementary School, now the site of the South Boston Branch Library. (Courtesy Frank Cheney.)

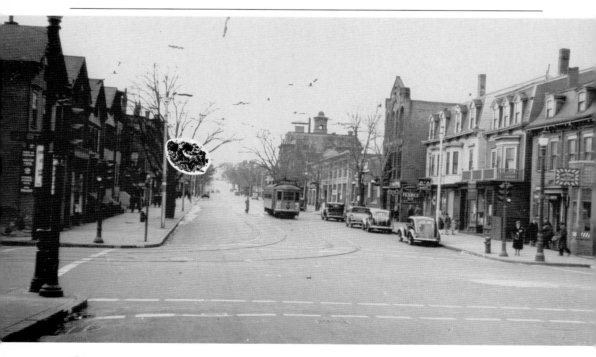

CHAPTER

2

PLACES OF WORSHIP

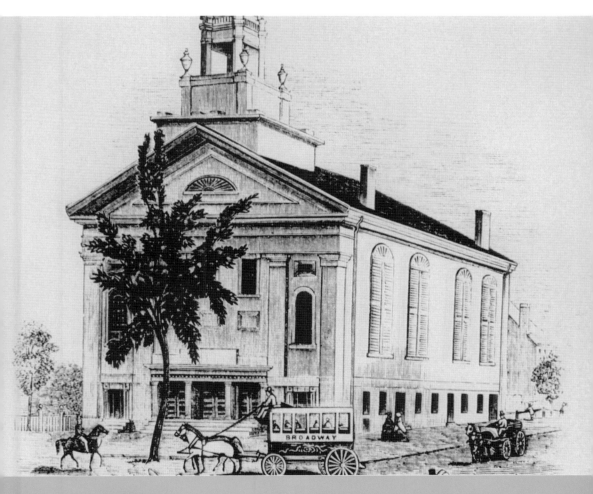

A Broadway horse-drawn omnibus, which connected City Point to downtown Boston, passes in front of the South Baptist Church, built in 1830 at the corner of West Broadway and C Street. The church was originally the First Church in Charlestown and moved and reerected in South Boston. An impressive Greek Revival meetinghouse with an urn bedecked belfry, it served the emerging community until it built a larger church at the corner of L and East Fourth Streets and became known as the South Baptist Church. (Courtesy South Boston Branch Library.)

St. Matthew's Episcopal Church was built in 1860 on West Broadway near F Street and is the oldest Episcopal parish in South Boston. A small Victorian Gothic batten-board wood church with barge board trimming and an asymmetrical bell tower, it was later covered in mastic and much of the decorative details removed. Today the church is used by St. John the Baptist Albanian Orthodox Church, and St. Matthew's built a modern place of worship on East Fourth Street, on the former site of the Church of the Redeemer, a small wood-shingle chapel built in 1885. (Author's collection.)

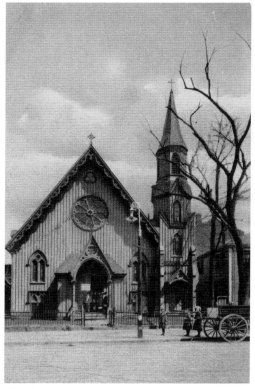

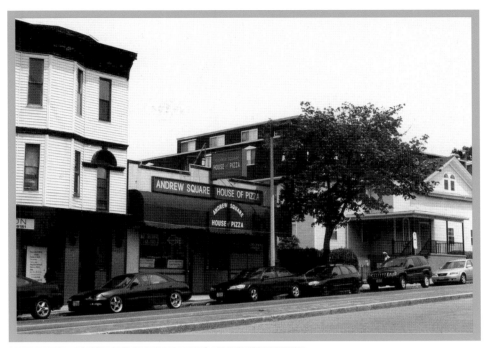

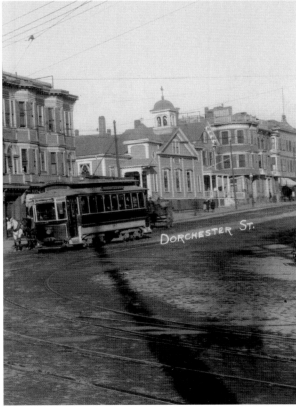

DORCHESTER ST.

The former Unity Chapel is on Dorchester Street near Andrew Square and was established in 1859 by the Unitarian Society. From 1859 to 1899, Unity Chapel was run by the benevolent fraternity but was later sold in 1900 to the Archdiocese of Boston, which consecrated it to St. Monica, the mother of St. Augustine. It was later used as St. Paul's Catholic Book and Film Center and recently has been converted into affordable apartments. (Courtesy of Frank Cheney.)

The Church of Our Lady of the Holy Rosary was on West Sixth Street between C and D Streets. Built in 1884, the parish was within walking distance of three other Roman Catholic churches, SS. Peter and Paul Church on West Broadway, St. Peter's Lithuanian Church on West Fifth Street, and St. Vincent de Paul on E Street, which is indicative of how many Roman Catholic families were moving into South Boston by the late 19th century. Today the site of the church is a housing development of the City of Boston. (Author's collection.)

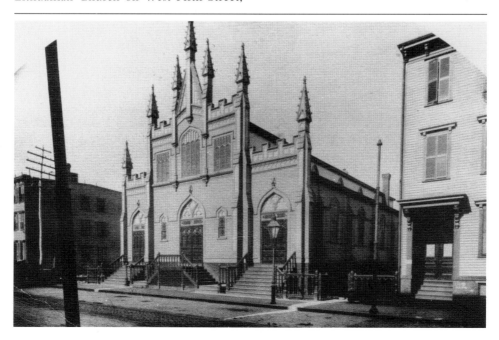

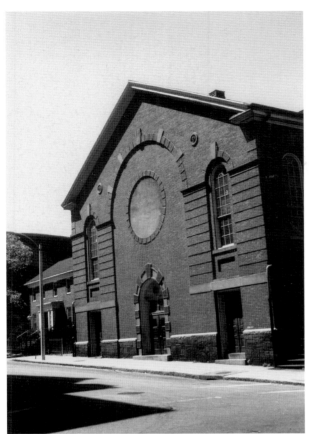

The former Gate of Heaven Church was designed by noted architect Patrick C. Keeley and is at the corner of East Fourth and I Streets. In 1863, this small redbrick Italianate chapel was erected for the growing number of Roman Catholics in the neighborhood, and the present church, built in 1900 across the street, was said to be "a perfect picture of architectural beauty and one of the best in New England" at the time of its erection. Today the former church serves as a parish hall and Sunday school hall. (Courtesy South Boston Branch Library.)

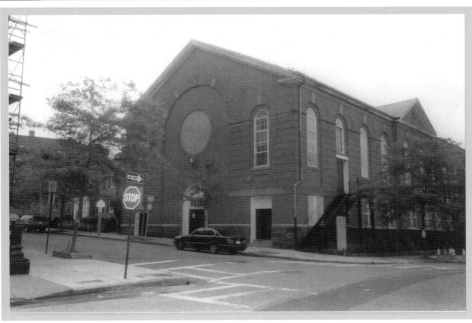

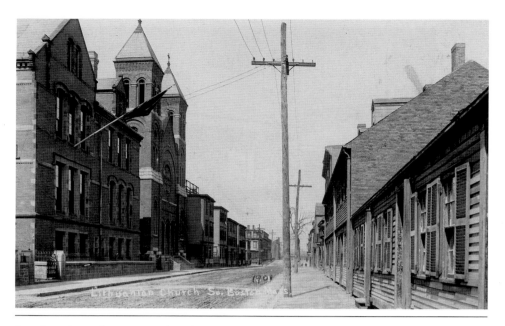

St. Peter's Lithuanian Church was a twin-towered Romanesque Revival church built in 1904 on West Fifth Street, facing West Broadway. In 1895, the first Lithuanian religious services where held in Holy Trinity Church in Boston's South End, and the building of this church followed shortly thereafter. Today the church has been closed by the Archdiocese of Boston, and the Samuel Gridley Howe Primary School, built in 1874, on the left has been demolished and is used as a parking lot. (Courtesy South Boston Historical Society.)

SCHOOLS

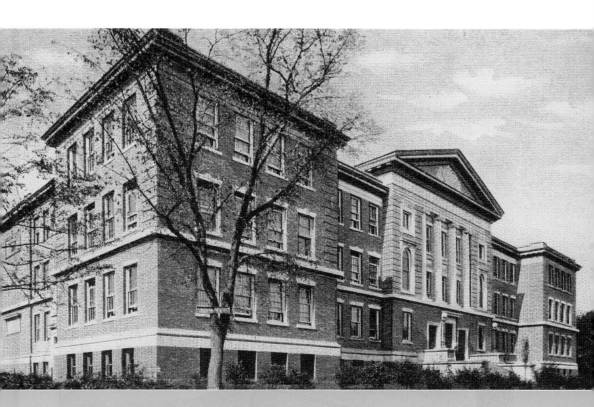

South Boston High School was designed by Herbert D. Hale and built in 1901 at 95 G Street, on the former site of the redoubts on Dorchester Heights during the American Revolution, and is sited on the highest point in South Boston. The impressive pedimented facade can be seen throughout South Boston, and it was a major achievement for a local high school to be established a century ago. (Author's collection.)

The Hawes School was a redbrick schoolhouse built in 1823 and named for John Hawes (1741–1829), a wealthy benefactor of South Boston in the early 19th century. This school was built on West Broadway near F Street; the Mezeppa Firehouse was on the left and later replaced by St. John's Methodist Episcopal Church. Today the site is the Mount Washington Savings Bank and the municipal parking lot. (Author's collection.)

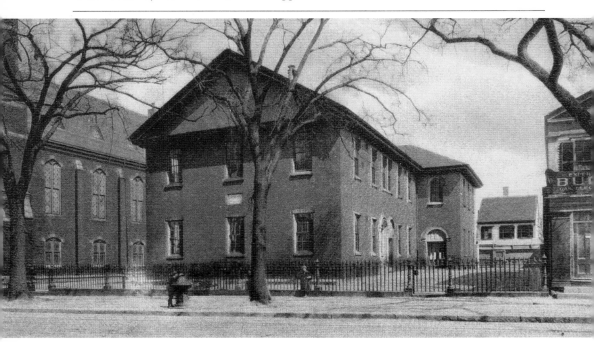

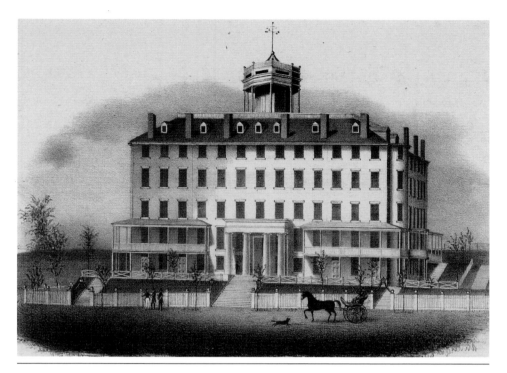

The Perkins Institute for the Blind was established in 1829 to educate the blind. This etching was from sheet music for "Mount Washington Quick Step," composed by pupil Alexander Messinger. Moving to the former Mount Washington Hotel on East Broadway between H and G Streets in 1839, Dr. Samuel Gridley Howe pioneered his theories on education and was greatly assisted by Thomas Handasyd Perkins, whose generosity and financial support led to the school being named in his honor. The Perkins School moved to Watertown in 1911, and the South Boston Municipal Courthouse, designed by James E. McLaughlin, was built in 1913 on the site. (Author's collection.)

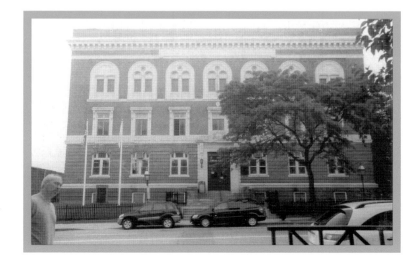

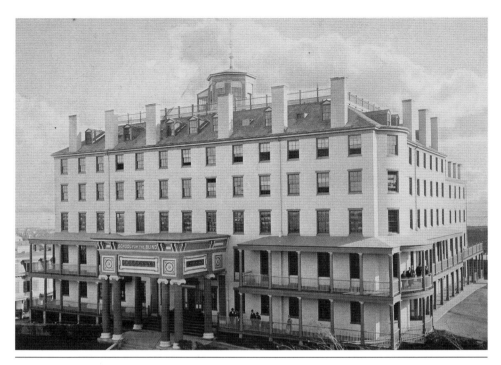

The "School for the Blind," as the signboard states above its Ionic portico entrance, served an important need in New England with Dr. Samuel Gridley Howe, principal of the Massachusetts Asylum for the Blind, offering hope. For decades, he, and later his son-in-law Michael Anagos, offered education, vocation, and security at the school for his blind pupils. In 1913, the South Boston Municipal Building was built on the site, designed by James E. McLaughlin. (Author's collection.)

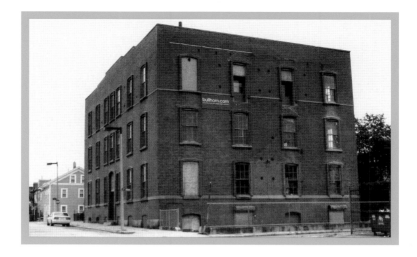

The Lawrence School, originally known as the Mather School, was built in 1856 on B Street between West Second and Athens Streets and was named for Amos Lawrence, a wealthy Boston merchant and generous benefactor of the school. Once the largest school in mid-19th-century Boston, it is the oldest surviving schoolhouse in South Boston. It was later sold and used for a variety of businesses and office space and today is being converted to condominiums. (Author's collection.)

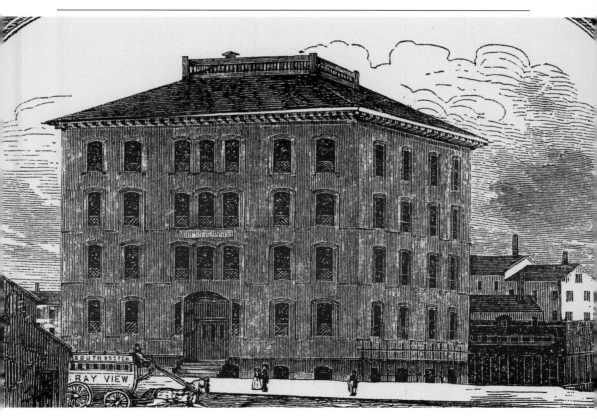

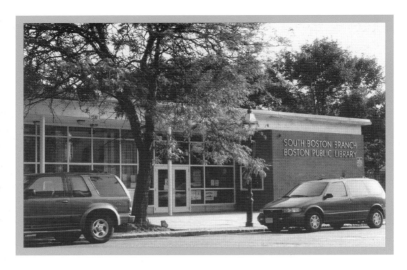

The Lincoln School was on East Broadway between I and K Streets and was named for Frederick W. Lincoln Jr., mayor of Boston from 1858 to 1860 and again from 1863 to 1866. Built in 1859, the four-story granite and redbrick 13-room school was originally a coeducational school. The South Boston Branch, Boston Public Library, was built in 1959 on this site and was the second branch library, established in 1872 in the city. (Courtesy South Boston Branch Library.)

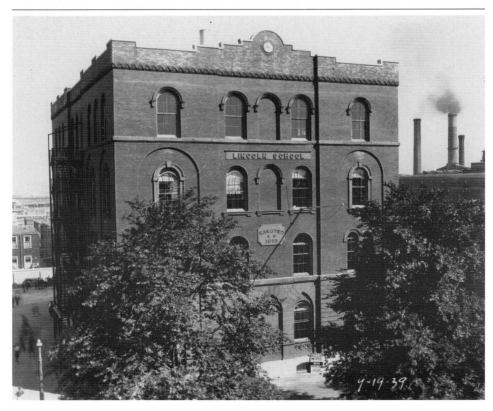

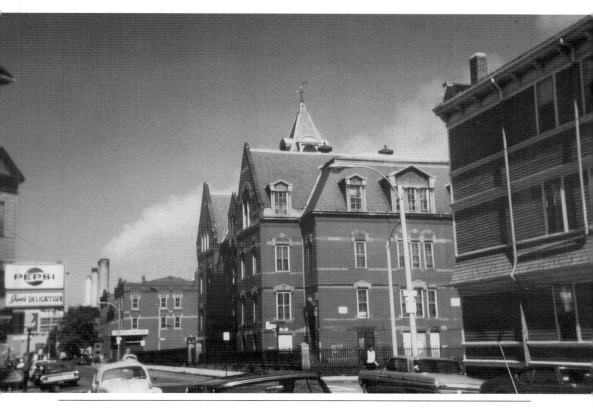

The Gaston School was built in 1873 at the corner of L and East Fifth Streets and named for William Gaston, mayor of Boston from 1871 to 1872 and governor of Massachusetts. Built in 1873, the three-story school was built of red brick and brownstone and had massive dormers and a clock tower that also acted as an early ventilating system for the 14 classrooms. The school was demolished in 1972, and the Monsignor Powers Senior Housing complex was built on its site. (Courtesy South Boston Branch Library.)

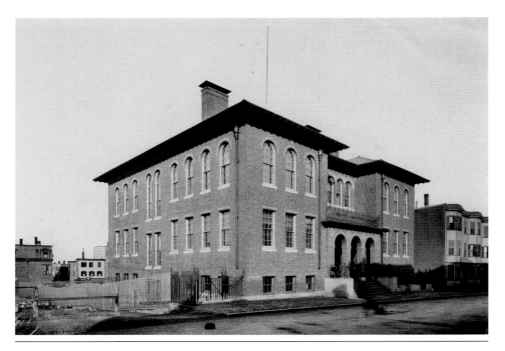

The Choate Burnham School was designed by Edmund March Wheelwright, city architect of Boston and a partner in the architectural firm of Wheelwright and Haven. The entrance of three arches with a bank of arched windows above gave an elegant aspect to the schoolhouse, which was only eight classrooms. The former grammar school was used as the South Boston Heights Academy in the 1970s and 1980s but was converted to condominiums about a decade ago. (Author's collection.)

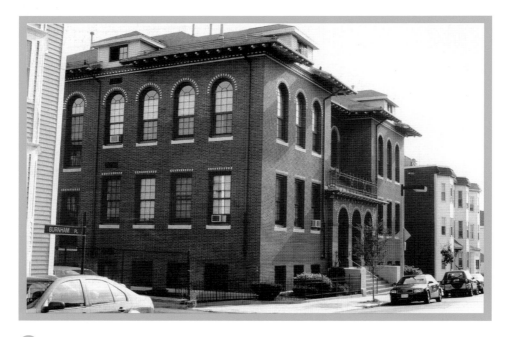

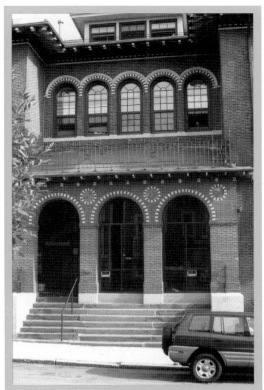

The Choate Burnham School is at the corner of East Third Street and Burnham Place and was designed by Edmund March Wheelwright, city architect. Erected in 1894, the eight-room, yellow brick schoolhouse was named in honor of Choate Burnham, a prominent resident of South Boston, coal and wood merchant, and member of the Boston School Committee in 1891 and 1892. Today the former school has been converted to condominiums. (Author's collection.)

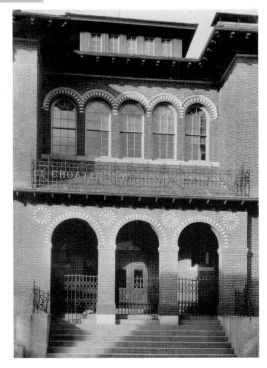

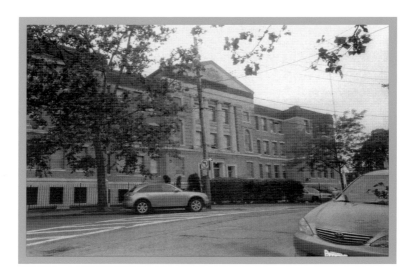

The South Boston High School was designed by Herbert D. Hale and built in 1901 on Telegraph Hill facing G Street. The impressive Colonial Revival school was built of mottled gray brick and limestone trimming and four engaged Ionic columns supporting a dentiled pediment. As South Boston did not have a high school until this building was built, it was a major achievement by residents after many years of petitioning city officials and equally impressive as to its prominent site. (Author's collection.)

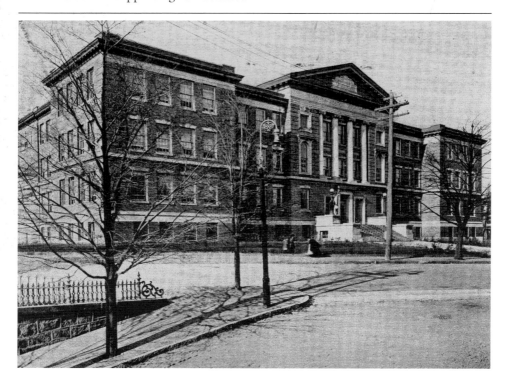

NEIGHBORHOOD INSTITUTIONS

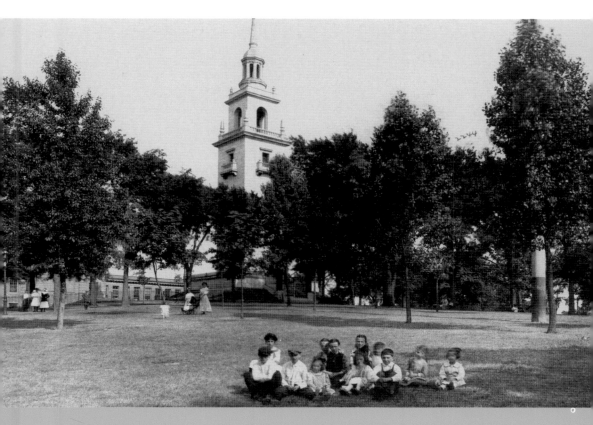

A group of children relaxes on the lawn at Thomas Park about 1909 as the impressive Dorchester Heights Monument rises above trees in the background. Built in 1902 and designed by the Boston architectural firm of Peabody and Stearns (who later built the Boston Customs House Tower), this white marble monument memorializes the evacuation of Boston by the British on March 17, 1776, which is now a holiday known as Evacuation Day. The tower, recently restored by the National Parks Service, is an impressive and prominent part of the heights. (Courtesy South Boston Branch Library.)

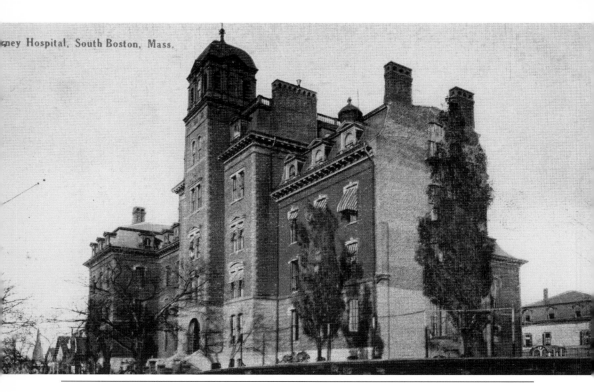

ney Hospital, South Boston, Mass.

The Carney Hospital was opened in 1863 in the former How Mansion on Harbor View Street on Telegraph Hill, or what was once known as Dorchester Heights. Established through the generosity of Andrew Carney (1794–1864) as a free hospital, it served all patients regardless of race, color, or religion. Today the site of the hospital, which moved to Dorchester Avenue in Dorchester Lower Mills in 1954, is part of Marian Manor Nursing Home. (Author's collection.)

NEIGHBORHOOD INSTITUTIONS

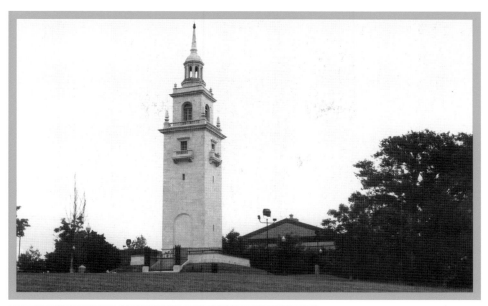

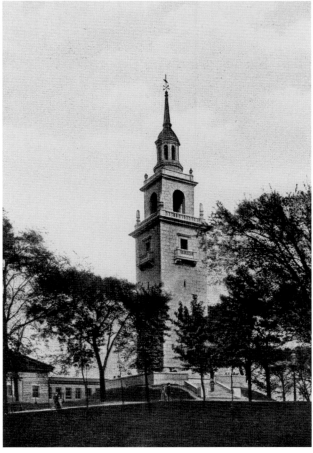

The Dorchester Heights Monument was designed by the Boston architectural firm of Peabody and Stearns and built in 1902 on the crest of Dorchester Heights to commemorate the site of the Revolutionary War encampment that led to the evacuation from Boston of the British troops and Loyalists on March 17, 1776, and what is known today as Evacuation Day. The Georgia white marble tower, reminiscent of a church steeple with an octagonal cupola surmounted by a weather vane, is today operated by the National Parks Service and has superb panoramic views of South Boston and Boston Harbor from its lofty vantage point. (Author's collection.)

The South Boston Municipal Building is at the corner of Dorchester and West Fourth Streets and at the time of its erection in 1868 had the municipal court, police station, and Engine No. 1 in South Boston. An impressive redbrick and granite Second French Empire design with an iron crested roof and belfry, it was remodeled in 1917, after which it served as Engine No. 1 and Ladder No. 5 of the Boston Fire Department before being converted to condominiums in the last decade. (Courtesy South Boston Branch Library.)

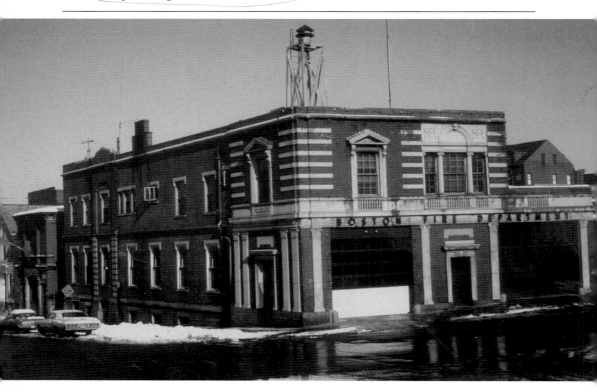

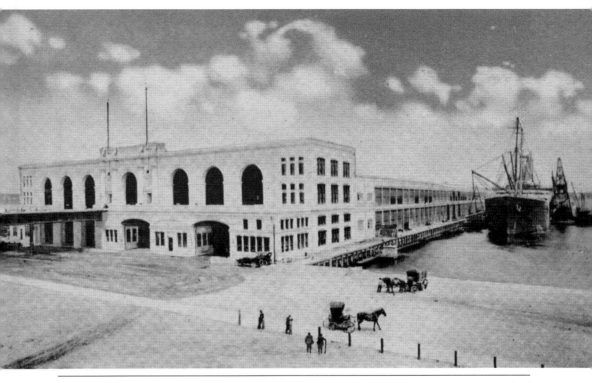

Commonwealth Pier was built in 1912 under the direction of the Port of Boston for the new, larger ocean liners docking in Boston. Built as a 1,200-foot-long dock, it was envisioned as being able to "accommodate at one time any two of the largest ocean steamships afloat and also two or three smaller vessels." After the 1960s, few ocean liners docked in Boston, and the building was remodeled as the World Trade Center, with shops and offices and the ferry to Provincetown using the north pier. (Author's collection.)

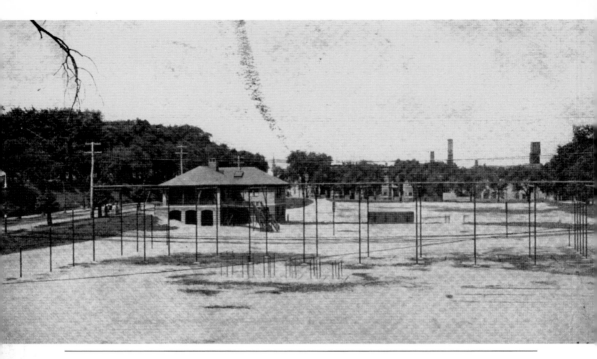

The M Street Playground (now known as the C. J. Lee Playground) was part of Independence Park and was laid out in 1898 on the site of the former city buildings off West First Street, including the Houses of Correction and Industry and the Boston Lunatic Asylum. M Street Playground had large playing fields (which were flooded in winter for ice-skating), tennis courts, and a playground building for use during inclement weather. The park along the East Broadway perimeter has the first Vietnam Veterans Memorial in the United States, designed by Harry Carroll and dedicated in 1981. (Author's collection.)

CHAPTER

5

ANDREW SQUARE

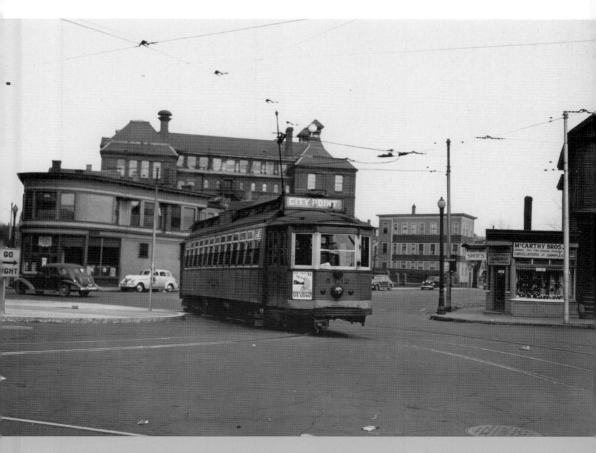

Streetcar 5432 approaches Andrew Square from Preble Street in 1941. Once known as Little Neck and later as Washington Village, the intersection of Dorchester Avenue and Dorchester, Southampton, Boston, and Preble Streets was renamed in memory of John Albion Andrew, the governor of the commonwealth during the Civil War. The large building rising in the distance behind the streetcar is the John A. Andrew School, built in 1878 at the corner of Dorchester and Rogers Streets; in front of it is the rounded bay of the Nolen Building. (Courtesy Frank Cheney.)

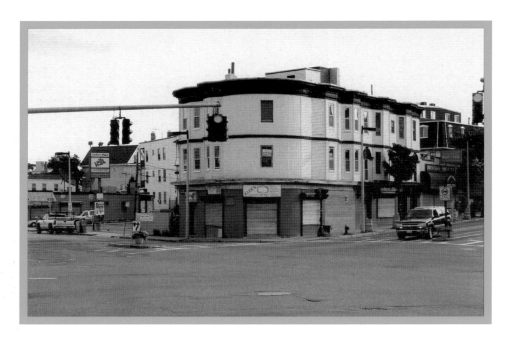

The impressive Colonial Revival–designed Duke Block, a commercial and apartment block, at the corner of Dorchester Avenue and Dorchester Street anchored Andrew Square on the east with Chamberlain's Pharmacy on the first floor. Seen in 1910, streetcar 387 approaches the intersection. On the right can be seen the former Unity Church, later St. Monica's Roman Catholic Church, and on the left the commercial businesses and tenements along Dorchester Avenue. (Courtesy Frank Cheney.)

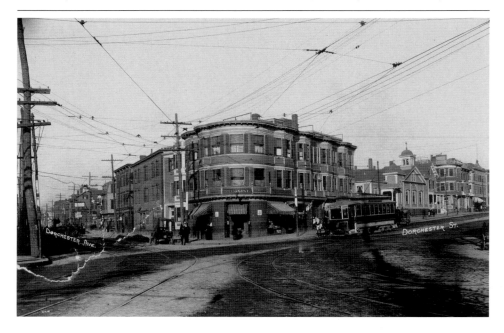

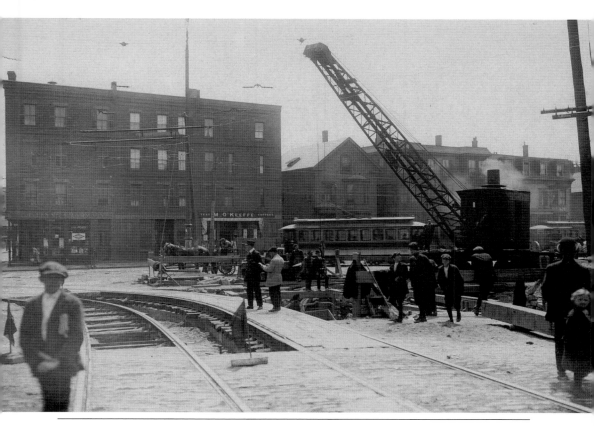

In 1916, Andrew Square was excavated for the extension of the underground subway that continued on to Ashmont Station. An excavator dredges the area at the foot of Southampton Street at the junction of Dorchester Avenue and Boston Street. On the far left, Flynn's Pharmacy and O'Keefe's Tea and Coffee Store were demolished when Preble Street was widened, and today the William T. Burke Building is located on the corner. (Courtesy Frank Cheney.)

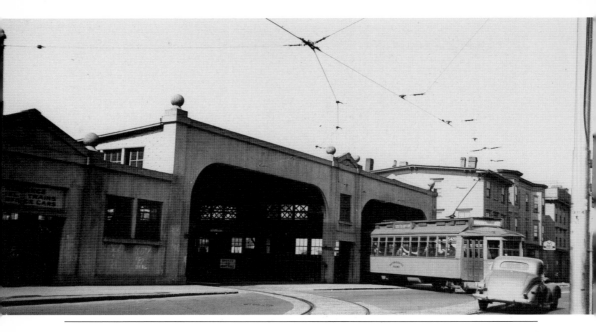

Andrew Square is a stop on the Red Line, which connects Ashmont Station in Dorchester with Alewife Station in Cambridge. A simple concrete reinforced structure, it was a major connection point for streetcars, which serviced South Boston, Dorchester, and Roxbury. Seen here in 1937, streetcar 5429 exits one of the Dorchester Avenue bays as it heads toward City Point. Today the station is a modern glass and metal structure with a soaring glass clock tower. (Courtesy Frank Cheney.)

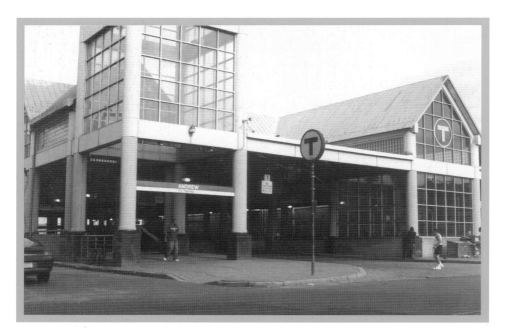

The streetcars (often referred to as surface cars) entered Andrew Square Station via Southampton Street and discharged passengers bound for other points, either by the subway or another streetcar. A passenger stands in 1942 on the right awaiting streetcar 5906, which is bound for Field's Corner via Geneva Avenue; these streetcars also provided transportation to Upham's Corner, Meeting House Hill, Geneva Avenue, Franklin Park, Columbia Road, or Dorchester Avenue, all in Dorchester. (Courtesy Frank Cheney.)

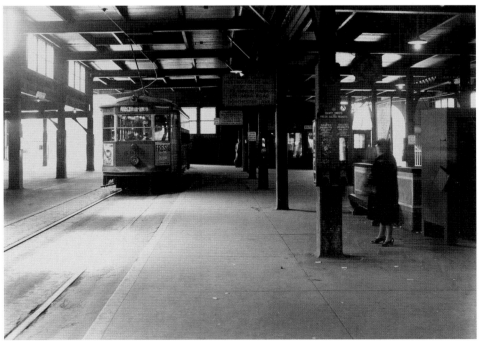

Streetcar 5618 approaches Andrew Square Station in 1947. A large neon sign above the entrance reads, "Rapid Transit 7 Minutes to Park St." in downtown Boston, a feat one would hope could be maintained six decades later! In the distance is Dorchester Avenue, and on the right of the streetcar in the distance, there is a vacant lot where Flynn's Pharmacy and O'Keefe's Tea and Coffee Store have been demolished to widen Preble Street, which connected the Old Colony Parkway (now Day Boulevard) and Andrew Square. (Courtesy Frank Cheney.)

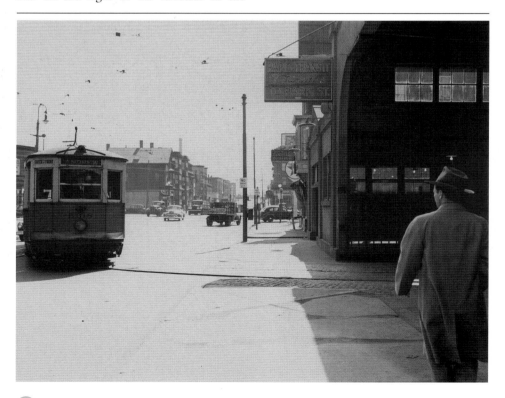

TRANSPORTATION

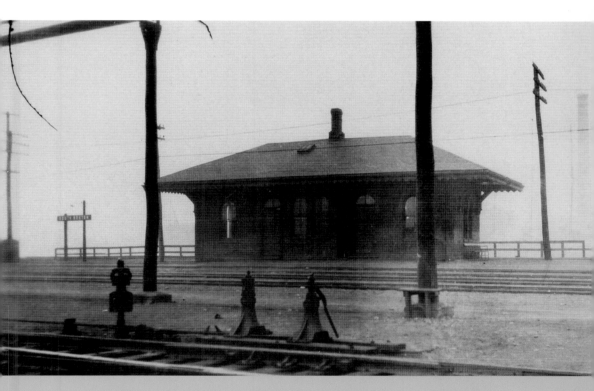

The South Boston Passenger Depot of the Old Colony Railroad, seen in 1913, was at the Dover (now known as the East Berkeley) Street Bridge. The Old Colony Railroad was founded by Nathan Carruth in 1844 and connected Kneeland Street (its Boston terminal) to the south shore and traveled through South Boston via what has become Old Colony Avenue, the former railroad tracks. Opened in 1862, it eventually became part of the New York, New Haven and Hartford Railroad until it was closed in 1932 and the tracks removed for the new automobile road. (Courtesy Frank Cheney.)

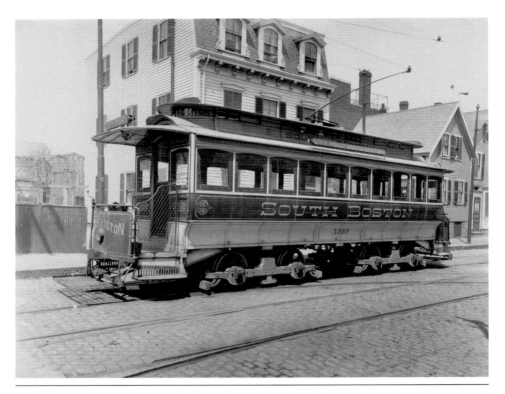

Streetcar 1360, seen in 1897 on P Street at the North Point car house, was originally two horse-drawn Highland Street Railway cars that were rebuilt for this spliced car, which operated by overhead electrical wires. This streetcar serviced City Point in South Boston, a major summer attraction for Bostonians who wanted to enjoy a day at the beach. The houses were on P Street in City Point. (Courtesy Frank Cheney.)

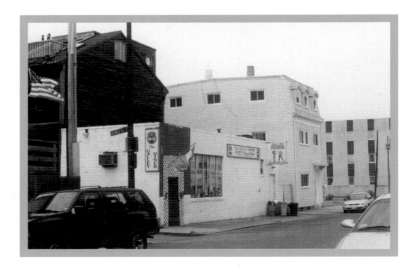

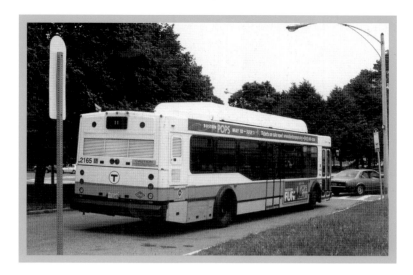

Streetcar 2658, an open, eight-bench summer car complete with striped canvas awnings, was built by the South Boston Railroad Company in 1883. Seen about 1900 at City Point, it is stopped in front of the Temperance House (formerly known as the Point Pleasant House), a well-known antialcohol resort, which has an advertisement prominently displayed under the sign offering "Ice Cold Beer." Today modern buses, such as bus 2165 seen here at City Point, provide every modern convenience. (Courtesy Frank Cheney.)

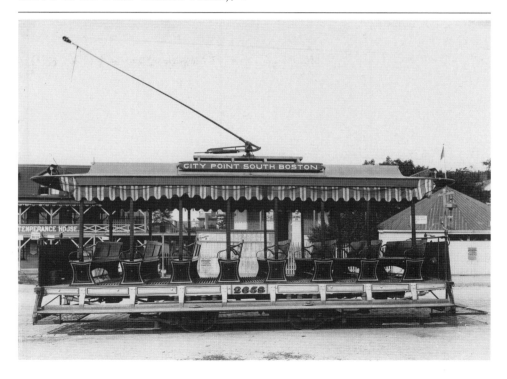

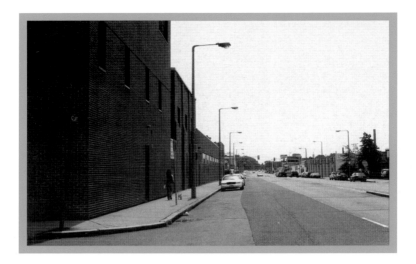

In 1915, as Dorchester Avenue (known as Federal Street prior to 1876) was excavated for the underground tunnel from Broadway Station to Ashmont Station, there were temporary trolley car tracks laid along Old Colony Avenue, the former right-of-way deeded in 1893 to the City of Boston when the railroad was discontinued. Here at the corner of C Street and Old Colony Avenue, men watch as the new tracks are installed. (Courtesy Frank Cheney.)

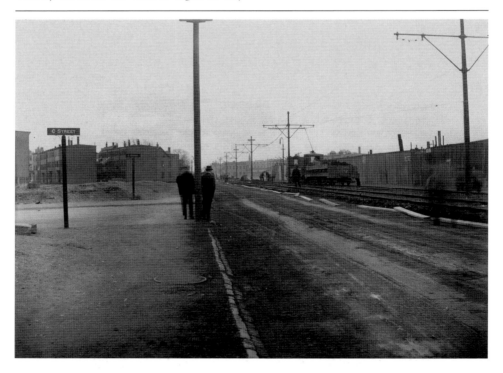

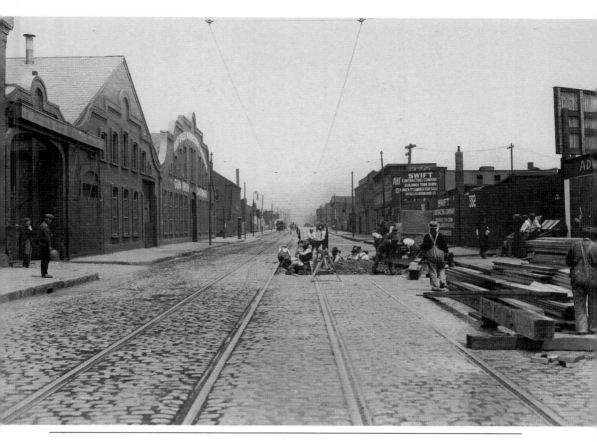

Dorchester Avenue, seen in 1913 in front of the Hunt–Spiller Company, had workers digging a test pit for the new underground tunnel that would connect Broadway Station to Ashmont Station. On the right is the Swift Contracting Company, which demolished buildings and sold brick and lumber. (Courtesy Frank Cheney.)

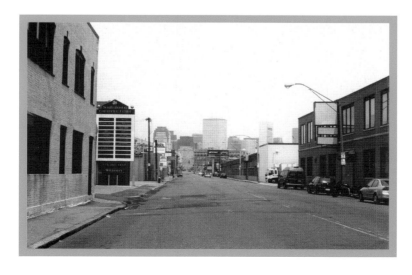

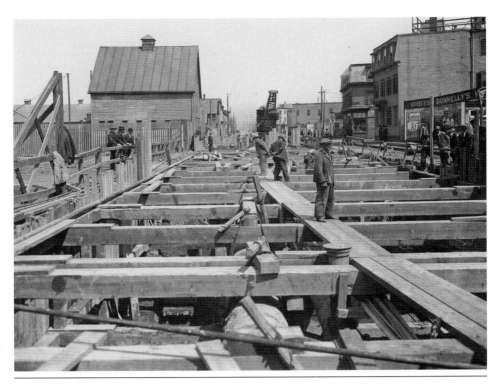

In 1915, the tunnel had been excavated on Dorchester Avenue between Broadway Station and the new Andrew Square Station. Workers laid wood pilings and supports for the snaking tunnel for the underground subway as curious onlookers inspect from the sidelines. (Courtesy Frank Cheney.)

In 1949, streetcar 3207 travels on Dorchester Street near Gates Street, connecting City Point to Andrew Square and then to Dudley Station in Roxbury. The mid–19th-century streetscape on the left is virtually intact five decades later. (Courtesy Frank Cheney.)

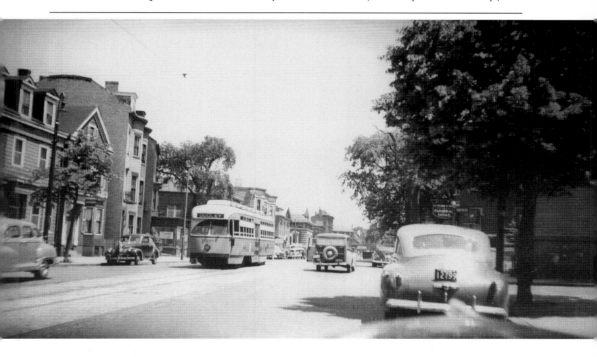

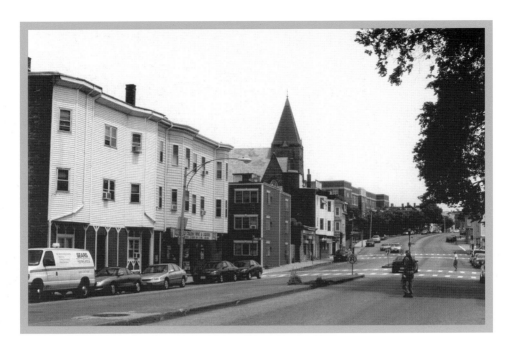

In 1949, streetcar 3206 traveled along Dorchester Street en route to Dudley Station in Roxbury. The soaring spire of St. Augustine's Church, designed by Patrick C. Keeley as a High Victorian Gothic church and dedicated in 1874, rises high above the shops and apartments along the street. (Courtesy Frank Cheney.)

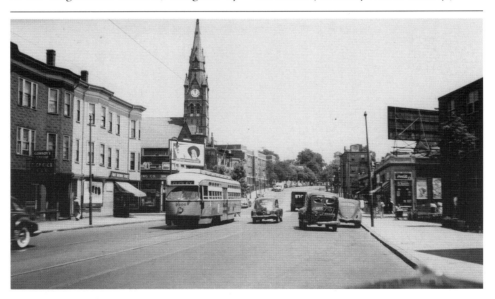

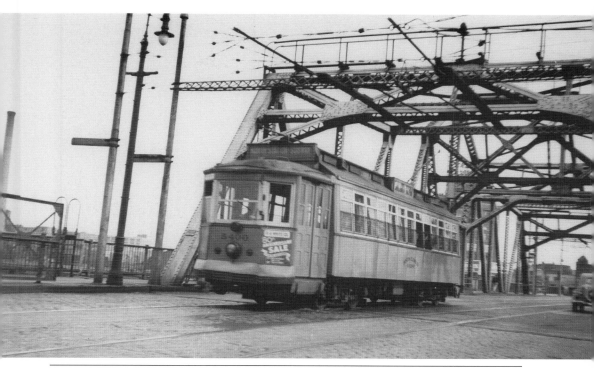

In 1938, streetcar 5400 heads toward the subway. (Courtesy Frank Cheney.)
North Station from City Point via the

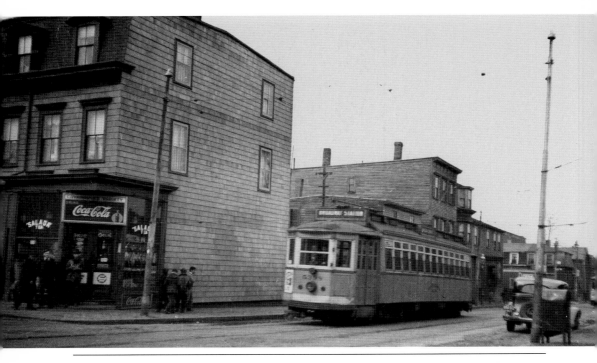

In 1940, streetcar 5398 approaches the corner of P and East Third Streets in City Point. A group of men, as young boys can be seen walking away, stand in front of Cavanaugh's Variety Store, prominently advertising both Coca-Cola and Salada Tea. (Courtesy Frank Cheney.)

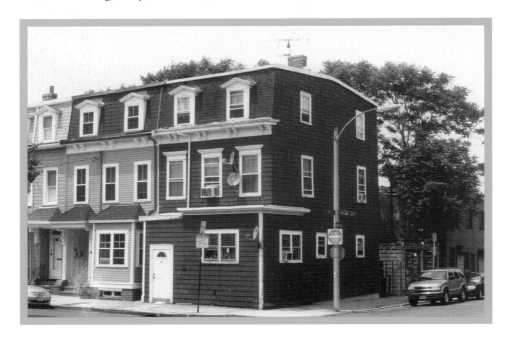

In 1938, streetcar 5434 travels on East Fourth Street from City Point. On the left is the Daniel Simpson House at 924 East Fourth Street, built in 1849, and an early Greek Revival house. (Courtesy Frank Cheney.)

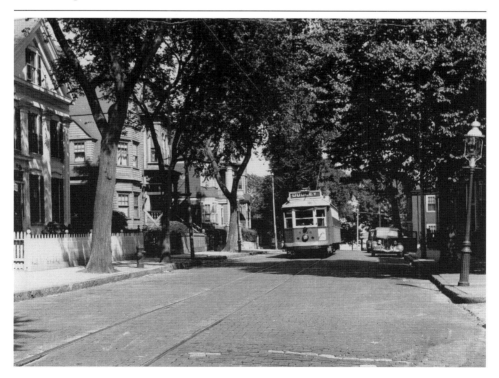

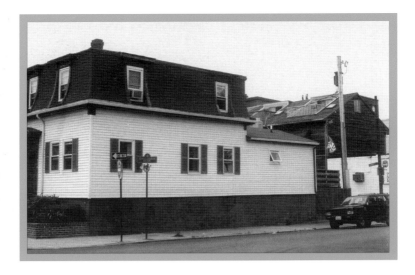

In 1946, streetcar 5504 is at P and East Second Street, opposite the North Point car house, as streetcars begin leaving for the start of the evening rush hour. The man in the center was the starter who oversaw the overall service. (Courtesy Frank Cheney.)

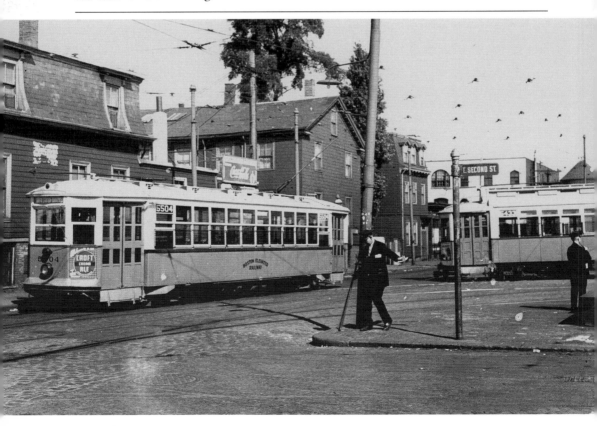

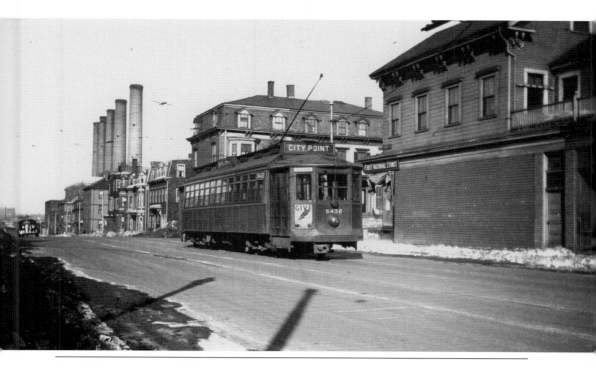

In 1936, streetcar 5432 crosses East Broadway on L Street, with the tall colonnade of smokestacks of the Edison Electric Illuminating Company, later the power station of the Boston Elevated Railway, rising in the distance. The First Trade Union Bank is on the right today. (Courtesy Frank Cheney.)

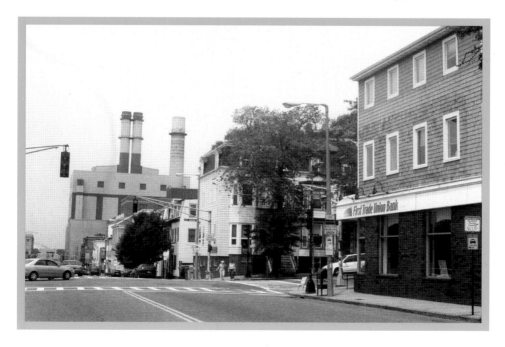

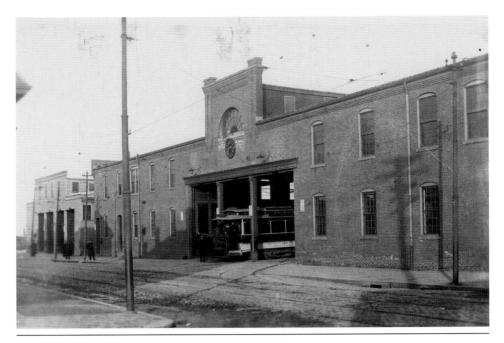

The North Point car house was a two-story redbrick structure built for the housing of streetcars overnight. Here streetcar 563 leaves the car house on March 12, 1892, on the first day electric streetcar service between South Boston and East Cambridge was instituted. On the far left are earlier wood car houses. (Courtesy Frank Cheney.)

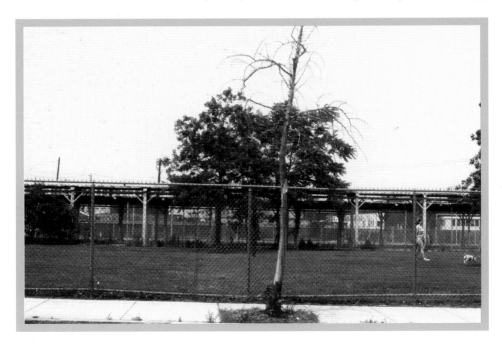

In December 1915, streetcar tracks at the corner of B Street and West Broadway were being repaired by workmen. The line was the Bay View Streetcar Line, which terminated at Bay View, City Point. On the right is J. C. Tibbetts and Company, a redbrick and granite building now shorn of its upper floors and the site of Sturgis Cleaners. (Courtesy Frank Cheney.)

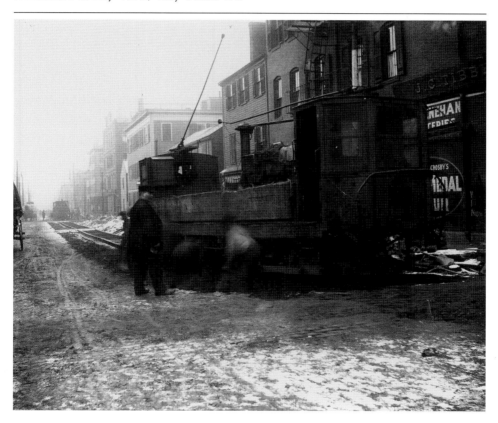

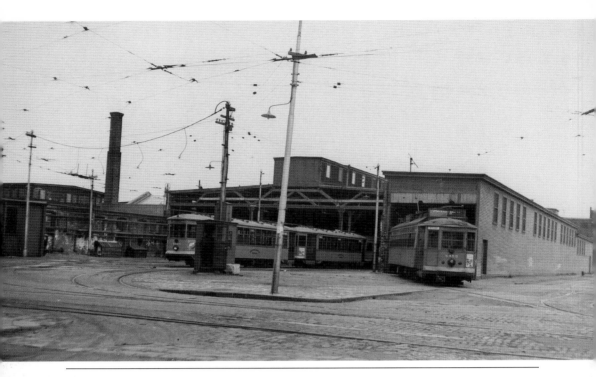

The new North Point car house was at the corner of P and East Second Street. Seen in 1938, the streetcars were housed in long one-story wood framed buildings that began to hum to life at dawn and continued until midnight. (Courtesy Frank Cheney.)

TRANSPORTATION

A Few Businesses

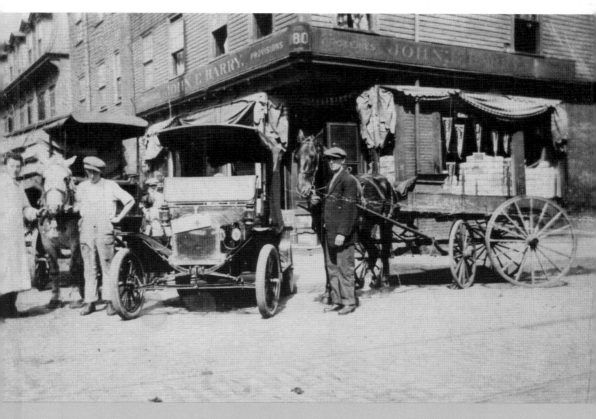

John F. Barry kept a general and provisions store on the first floor of an apartment block at the corner of B and West Fourth Streets at the beginning of the 19th century. Seen in front of the store, with horse-drawn delivery wagons flanking a new Model T automobile, are Bill Barry (left), Mike Mullane (center), and John Mullin. The horses are Easter Boy (left), who was bred as a racehorse, and Billy, a Grayhorse blue ribbon winner. Both were featured in the annual Boston Work Horse Parade. (Courtesy South Boston Historical Society.)

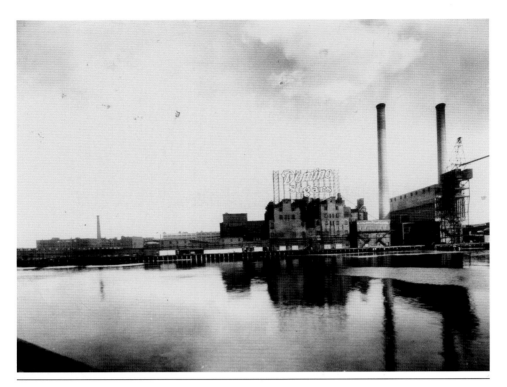

The Domino Sugar Refinery, one of the two leading sugar refineries in Boston (the other was Revere Sugar Refinery), was located near L and East First Streets. A huge illuminated two-story sign announced the sweet presence of the refinery, which has today been replaced by the power station. (Courtesy Boston Public Library, Print Department.)

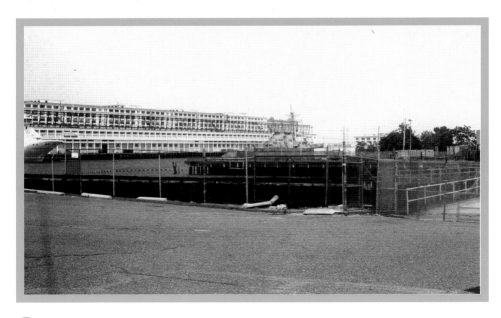

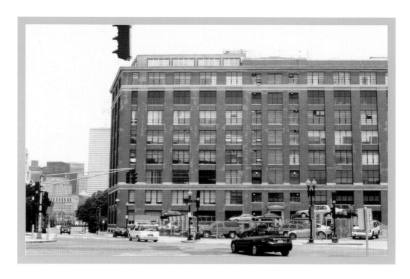

The Gillette Razor Blade Company was founded in 1901 by King Camp Gillette, who in 1904 received a United States patent on the first double–edged safety razor, which advertised "no stropping, no honing." The plant in South Boston, a group of eight-story buildings near Broadway Station at Dorchester Avenue, and the plant facility, which has increased in size over the last century, are known as the "World Shaving Headquarters." With advertisements, free razors provided to World War I soldiers, and quality products, Gillette and Company has remained prominent both locally and internationally. (Courtesy Boston Public Library, Print Department.)

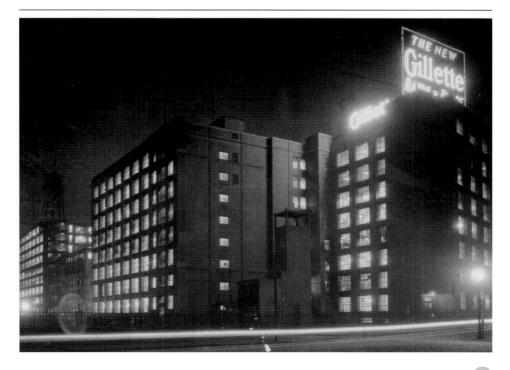

The South Boston Power
House of the Edison Electric
Illuminating Company, later
the power station of the Boston
Elevated Railway, was opened
in 1911 at the corner of Summer
and East First Streets to provide
electricity to the neighborhood
and Boston. On the right can be
seen the coal dock and facility
and on the left a building of
the Walworth Manufacturing
Company. Seen on the right are
the tracks of the Boston Elevated
Railway in 1938. (Courtesy
Frank Cheney.)

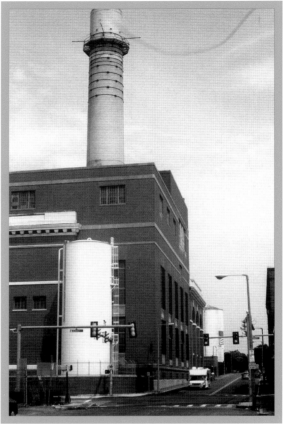

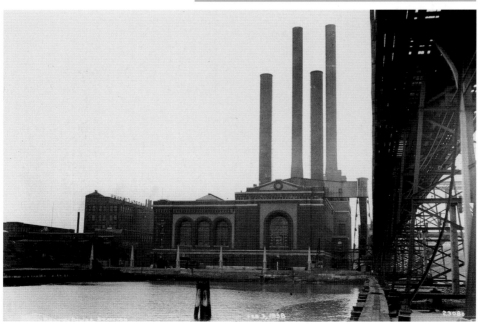

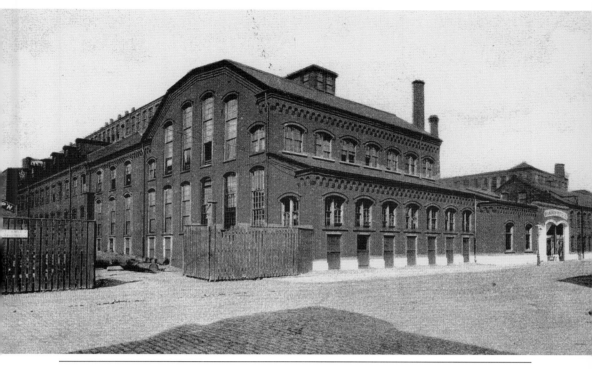

The Walworth Manufacturing Company, founded in 1842, was at the corner of East First and O Streets, adjacent to the South Boston Power House. Caleb C. Walworth was the inventor of the Walworth radiator, which was judged among the best available on the market at that time. The factory, which was designed by Fehmer and Page and which at the beginning of the 20th century employed upwards of 1,000 factory workers at any given time, had an extensive plant for the production of radiators and assorted supplies. (Author's collection.)

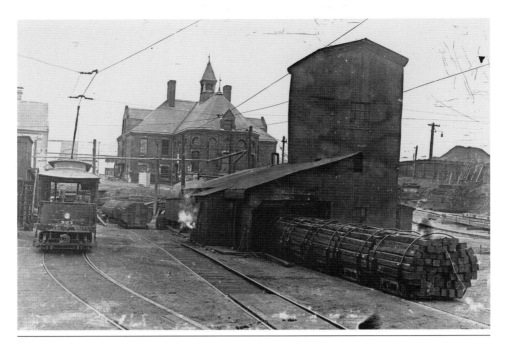

The Treating Plant in South Boston, seen in 1922, was housed in the former state institutional buildings, including the large rounded redbrick building, which was the former chapel of the House of Correction. The former streetcar on the left was used as a shifter for the treating plant. (Courtesy Frank Cheney.)

CHAPTER

8

ALONG THE
STRANDWAY

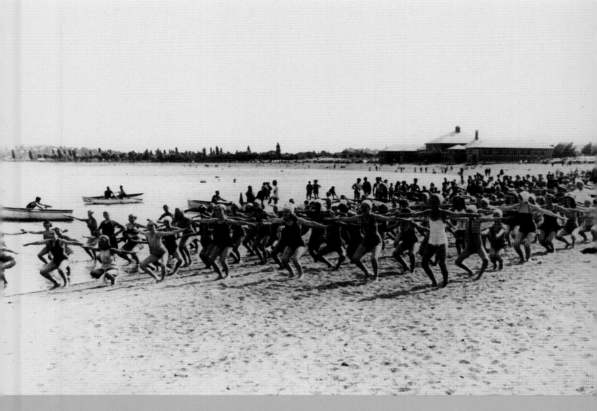

Dozens of women do their calisthenics on Carson Beach in South Boston in 1930, encouraged by people on the beach and in rowboats. In the distance is the Edward J. McCormack Jr. Bathhouse, built in 1925 as a bath and field house, which has recently been remodeled for light refreshments overlooking Dorchester Bay. In the distance, the area to the left of the bathhouse was developed for the Columbia Point Housing Project in the 1940s, which is today known as Harbor Point. (Courtesy South Boston Branch Library.)

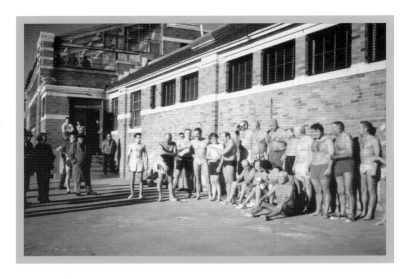

The L Street Brownies have been, since 1902, a stalwart and hearty group of men who brave the cold and frigid temperatures of a South Boston winter to relax on the snow-covered beaches and partake in a New Year's Day plunge into Dorchester Bay. Here four burly L Street Brownies read about their annual plunge in the newspaper in 1929 as they pose for the photographer. The L Street Bathhouse, a yellow brick and concrete one-story building at 1663 Columbia Road, has offered hot saltwater showers, exercise rooms, handball courts, a Vita glass solarium, and bathing for over a century. (Courtesy of the Boston Public Library, Print Department.)

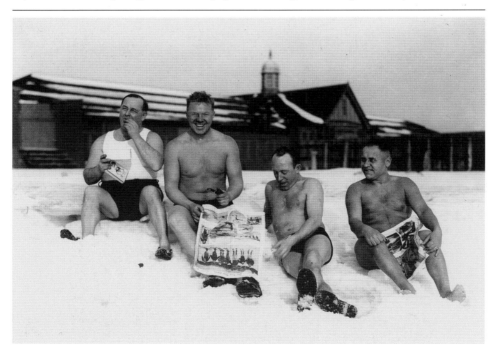

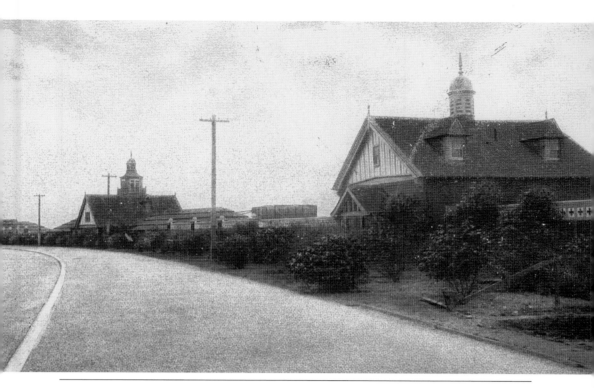

The original L Street Bathhouses were erected in 1865 and after 1901 were segregated for women and girls (on the right), and men and boys. They were in small wood framed buildings along the Strandway, as that part of Columbia Road was renamed after it was laid out beginning in 1889 as part of the Emerald Necklace by Frederick Law Olmsted and later the Olmsted Associates. These bathhouses offered bathing facilities, exercise rooms, and nude bathing with privacy ensured by wood palisade fences that extended into the ocean. Today this is known as the James Michael Curley Community Center, in memory of the legendary and notorious mayor of Boston. (Author's collection.)

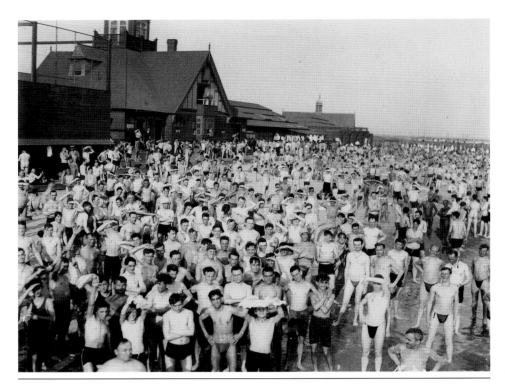

The L Street Bathhouse had opened in the 19th century as a place for public bathing as well as a public bathhouse, in an era when not every home had interior plumbing; above the entrance is engraved "Cleanliness of Body is Next to Godliness" with a bust of Neptune, king of the seas. The bathhouse was separated from the women's bathhouse by a wood planked fence that extended from the beach into the ocean. Here hundreds of thong-clad bathers pose for the photographer in the 1930s with the rear of the bathhouse seen in the distance. The present art deco–designed L Street Bathhouse was designed by J. M. Gray and J. P. Heffernan and built in 1931. (Courtesy of the Boston Public Library, Print Department.)

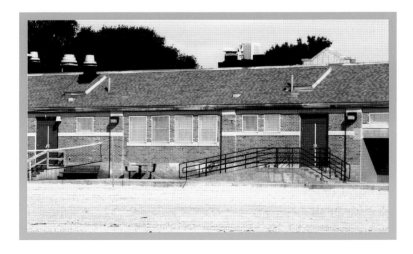

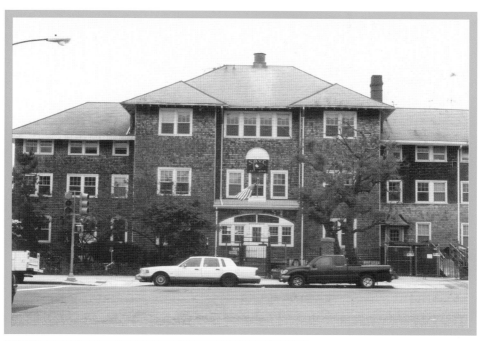

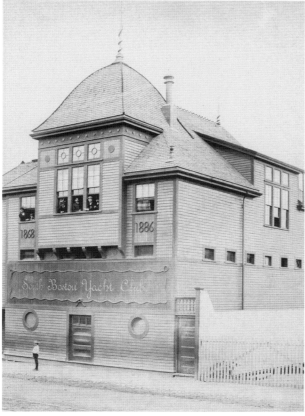

The South Boston Yacht Club was founded in 1868 with 59 members who enjoyed the amenities offered by City Point. The original clubhouse, a three-storied wood framed building with a center projecting tri-light windowed tower, was rebuilt in 1886 due to the rapid increase in membership. Incorporated in 1877, the South Boston Yacht Club was to sponsor its first regatta on Memorial Day that year, and this tradition still continues. As the Strandway was laid out, the clubhouse was demolished in 1899 and a new clubhouse built. The yacht clubs along Judge William Day Boulevard, as the Strandway is now known, have created an impressive streetscape since the boulevard was begun in 1889. (Author's collection.)

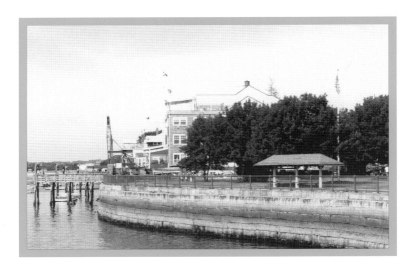

The new South Boston Yacht Club was designed by the Boston architectural firm of Maginnes, Walsh and Sullivan and was built in 1899 on the water side of the Strandway with an impressive granite embankment wall surmounted by an iron railing. Built on land that was formerly a salt marsh, its prominent situation makes it visible from Marine Park, which since it was begun in 1881 has attracted great attention. Also along this stretch of Day Boulevard are the Columbia Yacht Club and the Boston Harbor Yacht Club. (Author's collection.)

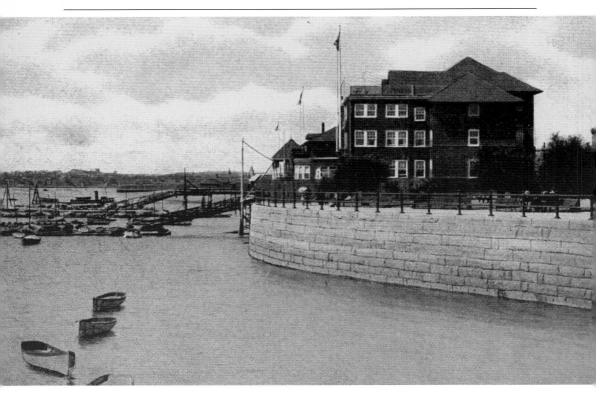

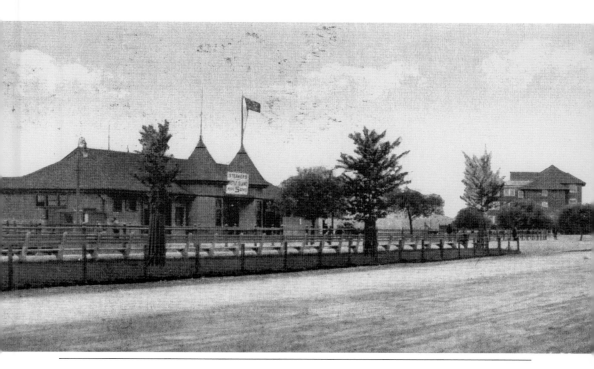

The Public Landing was on the Strandway (now Day Boulevard), opposite Farragut Road. The Thompson Island boat and other boats docked here, allowing passengers to enjoy an afternoon at Marine Park or an excursion to the outer islands. The building was later leased in 1927 to Larry and Maizie "Ma" Kelly, who renamed the building Kelly's Landing, offering deep-fried seafood and ice cream, which was continued by their family as a local institution on the site until 1994. On the right can be seen the side of the South Boston Yacht Club, built in 1899. (Author's collection.)

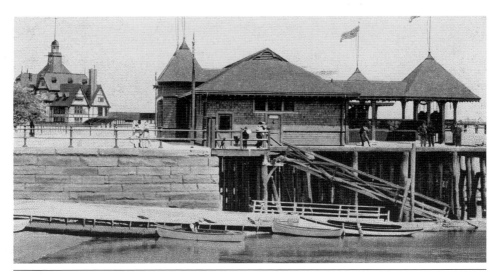

The Public Landing, later known for decades as Kelly's Landing, was built on wood pilings driven into Dorchester Bay. The building was a one-story shingle-style structure with conical roofs from which American flags flew high. The launch can be seen on the right, where the boats would dock; today the landing has been demolished and graded for a small park with benches overlooking the bay. On the left can be seen the Head House, a fantastical neo-Germanic structure designed by Edmund March Wheelwright. (Author's collection.)

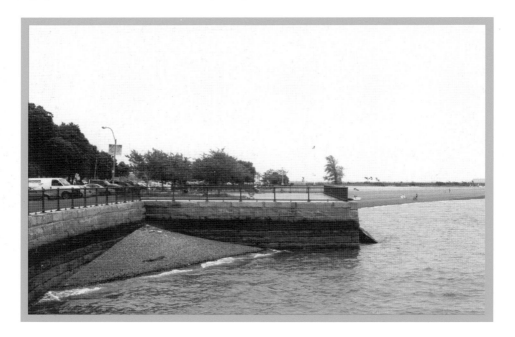

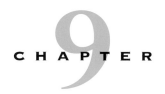

CHAPTER 9

MARINE PARK AND CASTLE ISLAND

Hundreds of people enjoy a Sunday afternoon stroll along the pier projecting into Dorchester Bay from the Strandway at Marine Park. Projecting well into the bay, the pier had gas lights and breathtaking panoramic views of the harbor islands and the city itself from a roofed shelter at the end, known as the Sugar Bowl. As Marine Park became a weekend destination during the summer months, it is remarkable to see how well dressed these people are, ladies with parasols to shade them from the sun and gentlemen with boaters and derbies. (Author's collection.)

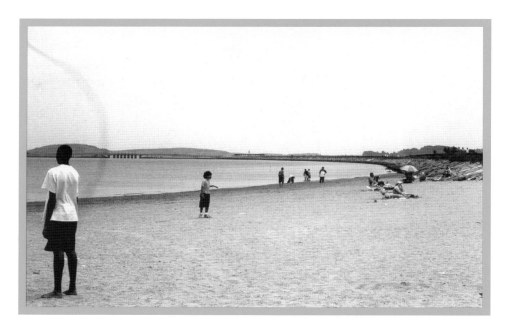

In 1906, a century ago, bathing at City Point was a very different thing than it is today. Entire families would come on foot, by streetcar, or by the public launch to enjoy a day either bathing in the ocean or just enjoying the warm sunshine fully dressed, women in feathered hats and men in derbies. On the left can be seen the pier projecting from the rear of the Head House and the bathing cabanas on the far left. Known as Pleasure Bay, the water provided an enjoyable afternoon. (Courtesy of South Boston Branch Library.)

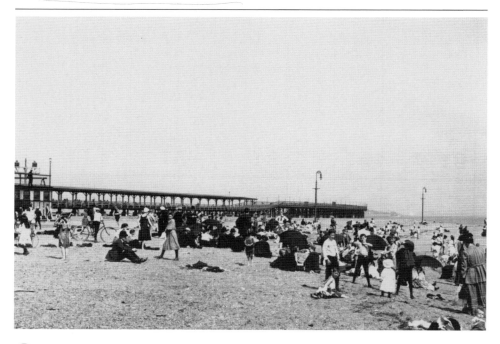

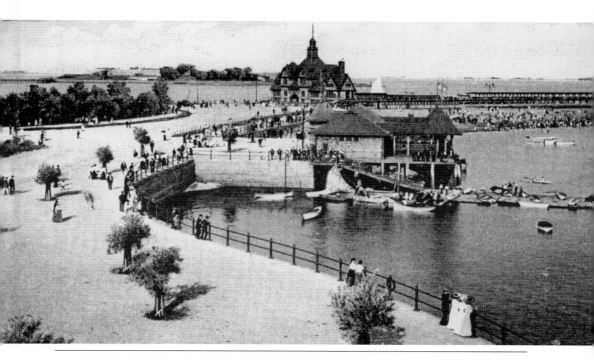

Looking along the Strandway, the Public Landing (Kelly's Landing) is seen in the foreground with the multi-roofed Head House in the distance. Frederick Law Olmsted, and later the Olmsted Associates, created Marine Park as an extension of the Emerald Necklace that surrounded the city of Boston, and the Strandway was to be laid out with panoramic views of Dorchester Bay with an attractive area that included public bathing, promenades, and attractions all within a short commute from any part of the city. (Author's collection.)

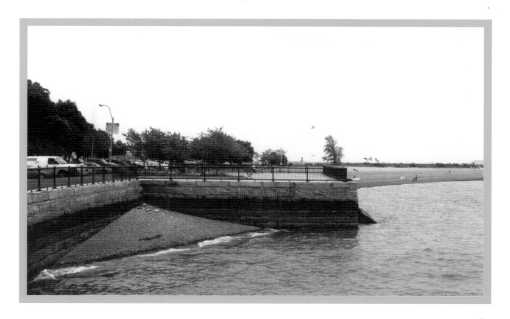

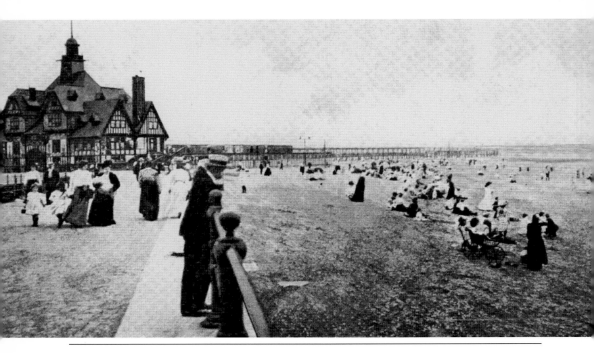

A straw boatered gentleman leans on the iron balustrade along the Strandway admiring the panoramic vistas of Dorchester Bay and the hundreds of bathers. On the left can be seen women and children enjoying a promenade along the Strandway, with salt air and stiff ocean breezes and with the Head House in the distance. (Author's collection.)

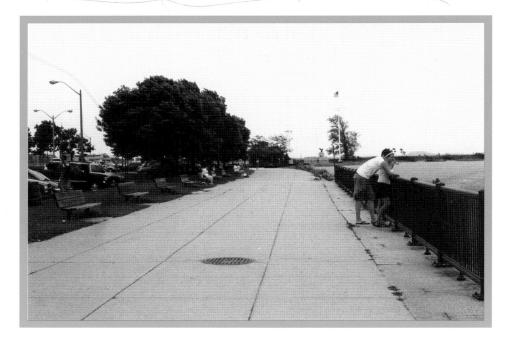

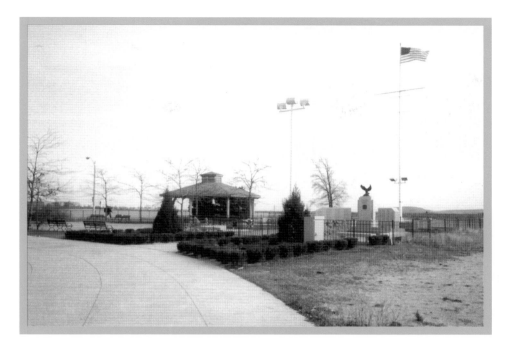

The image of carefree summer afternoons at Marine Park is obvious in this photograph from 1910. As young children bathe in the ocean in the foreground, fully dressed adults watch them and enjoy the sunny afternoon and the bucolic setting. After a day of sun, the Head House offered ice cream, iced tea, and other cooling refreshments in baronial-style halls, or people could enjoy them as they strolled along the Strandway. (Author's collection.)

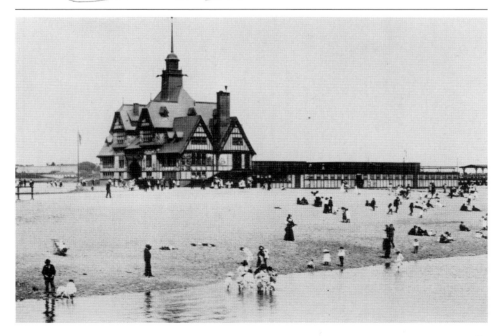

The Head House was probably the most architecturally significant, if not most exuberant, building ever built in South Boston. Designed with Germanic Tudor detailing, with wattle and daub and polychromatic detailing, the center entrance building had banks of leaded glass windows, carved oak details, and a multitude of rooflines with a central louvered tower with a clock and corner gargoyles. Today the site is marked by the World War II Memorial, the John E. Powers Memorial, and the Thomas Fitzgerald Gazebo. (Author's collection.)

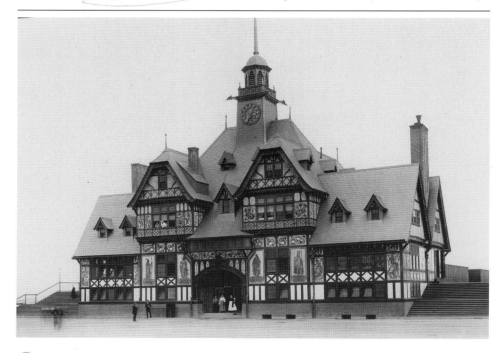

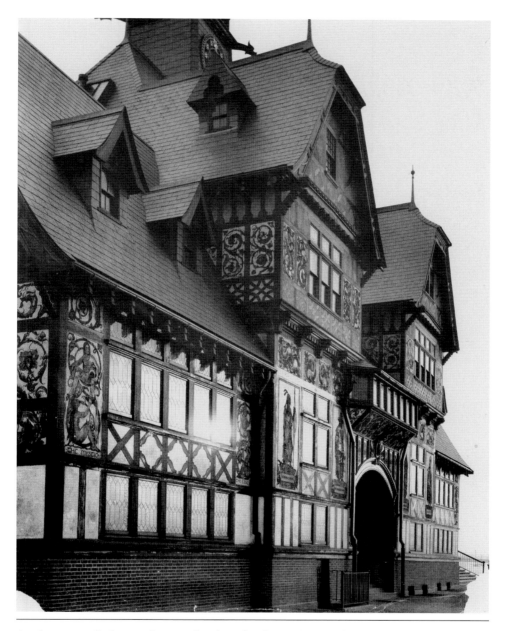

A close-up of the exuberant facade of the Head House at Marine Park shows the whimsy of architect Edmund March Wheelwright. A rambling Germanic Tudor Revival building, it was a center-entrance pavilion with projecting dormers above with banks of leaded glass windows, fanciful decorative work, bracketed moldings and overhangs, and a soaring clock tower with gargoyles on its four corners. The Head House was famous for its dining and dancing facilities at night but was destroyed by a disastrous fire in 1942 and demolished. (Author's collection.)

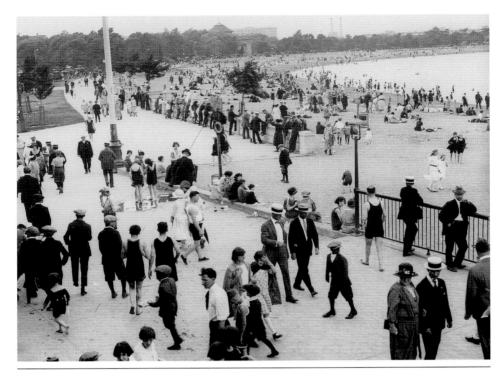

The Strandway, as Columbia Road was known, was laid out beginning in 1889 as a serpentine roadway that had broad sidewalks that lined the beach. On weekend afternoons, with accessibility by streetcars that networked throughout the city, thousands of Bostonians came to Marine Park to stroll along the sidewalk, bathe in the ocean, dine at the Head House, visit the Boston Aquarium, or just relax on the elegant balustrades that overlooked the sanded beach. With broad green space and shade trees, the Strandway was a continuation of Frederick Law Olmsted's Emerald Necklace, a miles-long green space that surrounded the city. (Courtesy of the Boston Public Library, Print Department.)

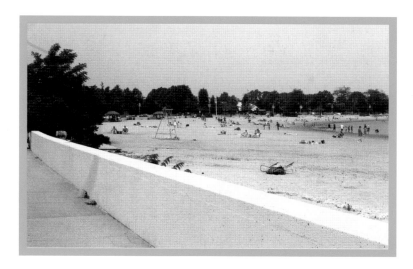

Looking from a window in the Head House about 1930, the beach had people both strolling in street clothing as well as bathing suits, enjoying the afternoon. Edmund March Wheelwright had designed an impressive balustrade that edged the sidewalk (and wispy shade trees), allowing people to sit or lean on it as they looked out to Boston Harbor. On the far left can be seen the Boston Aquarium and in the center the army base (now the Boston Design Center), and a large passenger liner enters Boston Harbor where it will eventually dock at the Commonwealth Pier in South Boston (now the World Trade Center). (Courtesy of the Boston Public Library, Print Department.)

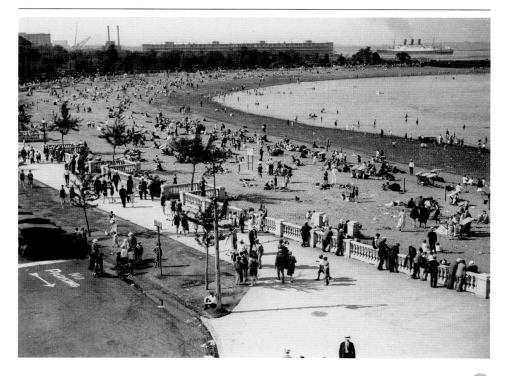

The beach at Marine Park was an interesting combination of bathers, some lounging in rented striped awning chairs, fully dressed walkers, and even a helmeted policeman in the center of the photograph, all of whom came to enjoy the invigorating salt air. On the left, people swim toward a large floating wooden barge where others are already standing, looking out toward Boston Harbor, and on the right can be seen Kelly's Landing with the yacht clubs along the Strandway in the distance. (Courtesy of the Boston Public Library, Print Department.)

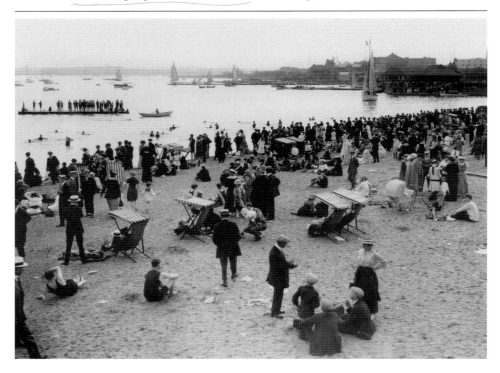

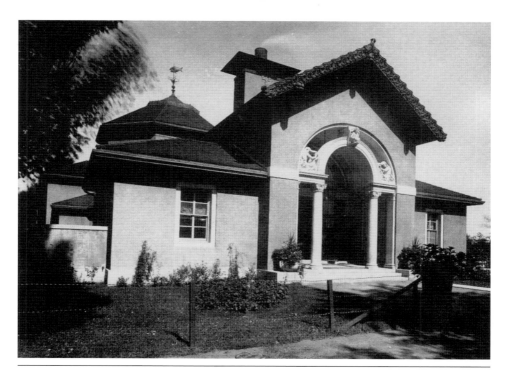

The Boston Aquarium was a large stucco and red tile roofed building designed by William Downer Austin and built in 1912 at Marine Park in South Boston from income derived from the Parkman Fund. The entrance was a large archway that had two columns supporting lintels that were surmounted by mermaids; the weather vane was surmounted by a bronze cod. The aquarium was a major attraction to Marine Park, and countless adults and children passed through its doors on a daily basis to marvel at aquatic marine life in large tanks until 1956 when it was demolished. Today a tennis court occupies a portion of the site of the aquarium. (Courtesy South Boston Branch Library.)

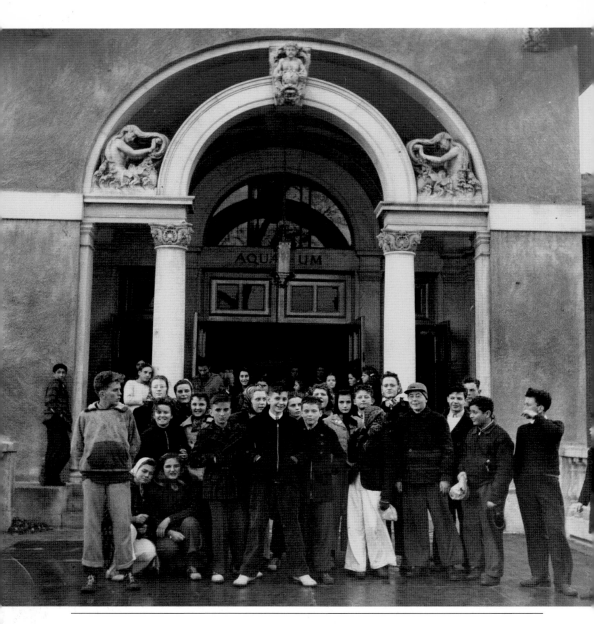

For decades, the Boston Aquarium was the destination of visitors of all ages, who could tour the 55 saltwater-filled fish tanks that contained aquatic life of all sorts, including large turtles, local fresh and saltwater fish, tropical saltwater specimens, and a number of seals. Here in the early 1940s, a group of children have just exited the aquarium on a school trip. The face of stucco was enhanced by William Downer Austin's stylized mermaids set into the open archway supported by marine and sea horse–inspired columns. (Courtesy South Boston Branch Library.)

Castle Island was named for a large castlelike fortification that had been built in the 17th century to defend the town of Boston. Once an actual island, it had a wood bridge built in the late 19th century, which made it accessible to the public, who continue, a century later, to walk, jog, and ride bicycles along the walkways encircling the granite fort. In 1892, Castle Island was joined to South Boston by a wide wood bridge that allowed walkers access to Fort Independence and the park established by the city in 1890. Today it has panoramic views of the city and harbor and on a warm summer evening is thronged with people. (Author's collection.)

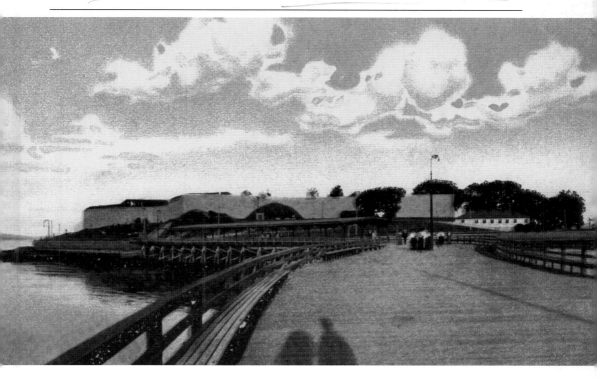

Across America, People are Discovering Something Wonderful. *Their Heritage.*

Arcadia Publishing is the leading local history publisher in the United States. With more than 3,000 titles in print and hundreds of new titles released every year, Arcadia has extensive specialized experience chronicling the history of communities and celebrating America's hidden stories, bringing to life the people, places, and events from the past. To discover the history of other communities across the nation, please visit:

www.arcadiapublishing.com

Customized search tools allow you to find regional history books about the town where you grew up, the cities where your friends and family live, the town where your parents met, or even that retirement spot you've been dreaming about.